WHY ARE YOU CREATIVE?

by **HERMANN VASKE**

WITH ANALYSES
BY JEFFREY K. ZEIG PH. D.

fivedegreesbelowzero Press

First published in the United States of America in 2002 by
fivedegreesbelowzero Press, L.L.C.
19 Winthrop Place
Maplewood, N.Y. 07040
phone: 973 275 9370
fax: 973 275 9372
e-mail: czimpfer@earthlink.net

ISBN 0-9708779-2-7

Distributed in the United States, Canada, Asia,
Latin America, Caribbean, Middle East by
How Design Books, an imprint of F&W Publications, Inc.
1507 Dana Avenue
Cincinnati, Ohio 45207
phone: 513 531 2222 / 800 289 0963
fax: 513 531 7107 / 888 590 4082

contact: Hermann Vaske's Emotional Network
Schmidtstrasse 12, 60326 Frankfurt am Main, Germany
phone: +49 (0) 69 / 739 91 80
fax: +49 (0) 69 / 73 10 21
www.why-are-you-creative.com
www.emotionalnetwork.com
www.hermannvaske.com

Art direction & cover design by Tommie Pinnow

Project co-ordination by Angela Krejci

fivedegreesbelowzero Press, L.L.C. would like to thank
Aquiles Ferrario for his encouragement which led to the
publishing of this book

Printed and bound in Germany

CONTENTS

PHOTO Anton Corbijn

Hermann Vaske is an author, director, advertising creative, producer and a professor of Communication.

He's one of the most awarded German creatives and the only one to win an Art Director's Gold medal, Cannes Awards, and Gold Awards at Clio for his commercials and the Grimme Award, Germany's TV Oscar, for his groundbreaking film *'The A-Z of Separating People From Their Money'* which stars Dennis Hopper.

After graduating in Communication from the University of Fine Arts in Berlin, and studying film directing at the American Film Institute in Los Angeles, Hermann worked from 1982-1994 as an Executive Creative Director of advertising agencies in Hamburg, Düsseldorf, New York and London, working with blue-chip companies such as Mercedes-Benz and Opel/General Motors.

Hermann's independent career started when he founded Hermann Vaske's Emotional Network working with clients like Deutsche Bahn, Audi, Volkswagen, Expo 2000, BMW and Hugo Boss.

Hermann Vaske's Emotional Network is an advertising agency and production company in Frankfurt which combines Hermann's own writing, producing and directing talents with those of other highly creative people such as Wim Wenders, Paul Arden, Mike Figgis, Tony Kaye, Mark Williams, Stein Leikanger, Malcolm McLaren, Julian Schnabel and Hugh Hudson.

The services and talents of Hermann Vaske's Emotional Network are used by advertising agencies, television stations and many other clients, to create, write, film and produce outstanding creative work, from conception to completion.

Hermann's previous television films include features on David Bowie and Yohji Yamamoto, as well as the feature length documentaries *'Best Sellers'* and *'The Ten Commandments of Creativity'* starring Dennis Hopper as Moses and Peter Ustinov as God. Shown around the world, from BBC 2 and Bravo [USA], to Hong Kong.

His latest book *'Standing on the Shoulders of Giants - Conversations with the Masters of Advertising'* was published in 2001. His *'Why Are You Creative?'* TV series will be launched on the the **ARTE**, the European cultural television channel in 2002.

Hermann's major project for the third millennium crosses two genres: investigative creative documentary, and pulp detective movie. It's called *'Who Killed the Idea?'*.

Hermann is a frequent speaker at creative and marketing conferences and seminars in Germany and abroad, and is a professor at the University of Applied Arts and Sciences in Trier, Germany.

THE DALAI LAMA

FOREWORD

Awareness is a quality inherent in all sentient beings, but among them human beings possess great intelligence. We are subject to a constant stream of positive and negative thoughts and emotions, but as human beings we are capable of positive change. If we are to be creative and employ our intelligence in a beneficial way then compassion, and concern for others, is invaluable.

All of us as individuals can play a part in shaping the world around us by applying our awareness and intelligence in joyful cooperation with others to create a more satisfactory order. However, we need to employ both the head and heart, which the Buddha referred to as a balance of wisdom and compassion. Placing greater emphasis on the intellect and ignoring the heart can cause great problems and suffering in the world. On the other hand, if we ignore our intelligence there is little difference between humans and animals. So, the two must be developed in harmony.

If the sheer power we are now capable of harnessing is not to have far reaching harmful consequences, there must be an accompanying inner development, a sense of responsibility for our world and the fellow beings with whom we share it. It is time to awaken our positive human potential by making the lives we lead meaningful. The answers collected in this book to the question, *Why Are You Creative?* are evidence of people trying to do just that.

September 28, 2001

"Why are you CREATIVE?"
Who in his right mind
would ask that question?

Who would ask any question
starting with a 'why'?
Socrates did,
was thrown into prison
and ultimately killed for that very reason.
So who today would ask any such question,
if not kids?
And who, if not a kid,
would expect an answer?

Seems to me that,
if we would dare to ask such childish questions
a little more often,
we would be more in touch
with some simple basics of life.
But then we consider ourselves
– and others –
too sophisticated to bother with basics.

In the most sophisticated of all contemporary crafts,
called 'advertising',
the key people are called CREATIVES.
(As if they had access to something professionally,
that the rest of us were cut off from,
a subscription to a secret source
that only they knew how to tap.)

Although Joseph Beuys suggested
that every man was creative,
and the Kinks sang it:
"Everybody's in showbiz,
everybody's a star..."
it is still not common knowledge
that CREATIVITY is not a privilege,

but part of the human condition.
So it's a good thing, after all,
that Hermann Vaske was childish enough
to ask enough people
who in turn were all childish enough to answer his question,
so that we can now, finally,
all consider it,
seriously or childishly:
Why are we CREATIVE?

And that raises another question:
Who the heck is Hermann Vaske?
Who is this guy
who travelled through six continents and 40 countries,
over seven long years,
to put his impertinent question
to more than a hundred celebrities;
who wouldn't even refrain from
approaching people on a street corner in Manhattan
or in a steam bath in Berlin!?

Obviously he is willing
to overcome any personal embarrassment
to accomplish a mission.
Obviously he is tenacious, too.
Obviously, he must be CREATIVE himself,
if he was able to actually assemble and release this book.

To find out more about him,
you'll have to meet him,
or have a look at his extraordinary documentary
about the world of advertising,
appropriately titled:
'The Fine Art of Separating People from Their Money'.

I'm glad I'm included in the book,
so I don't have to be one of those thousands
who now have to bombard Hermann with demands
to release a second volume,
so they can be part of it, too.

WHY DID I CREATE THIS by Hermann Vaske

In today's world, creativity has become a buzzword with a different meaning for everyone.

For Proctor & Gamble, it means 'new' on a box of soap detergent.

For Yehudi Menuhin, it meant a Stradivarius.

For Andy Warhol, creativity was linked to money: "The new art is business."

For Ayarton Senna, a racing car was its embodiment.

For Thomas Alva Edison, it was '10% inspiration, and 90% perspiration'.

For McDonalds, creativity probably means a jingle.

For Pele, creativity took place on a football field.

For Muhammed Ali, in a boxing ring.

George Lois says creativity is 1+1=3.

Edward de Bono took a lateral view: "There are people nowadays who are mere stylists, who call themselves creative."

So what is creativity?

I started my search for the meaning of creativity when I was a student. First at the University of Fine Arts in Berlin and then at the American Film Institute in Los Angeles.

In those days creativity seemed to me to be about communication.

So I became fascinated with mass communication and got my first job in an advertising agency.

I worked the 'creative departments' under 'creative directors' on 'creative briefs' producing 'creative work'.

But, if it was all so creative, why was so much of it dull, boring crap?

I had this discussion many, many times over many years.

I worked in advertising agencies in New York, Los Angeles, London and Germany, and was exposed to some of the brightest creative talents in the world.

Besides our work projects, we had many discussions about this, and similar topics.

All related, naturally, to creativity.

WHAT'S BEHIND THE WHY

Obviously, I am not unique in developing a compelling interest in the phenomenon of creativity. It has fascinated philosophers, artists, scientists and free-thinkers since the Muse was a child. And, yet, despite the huge importance of creativity to all great human endeavor, research had been sadly lacking. While the psychologist J P Guilford's efforts in the 1950s revived interest in this field, the study of creativity remained a relatively marginal topic, at least until recently.

In the last two decades, research into creativity has intensified significantly and the growing body of literature has stimulated a new generation of interest in the topic, while the raging theoretical debate has sent fresh blood surging through sclerotic arteries of presumption.

But new ground breaks slowly in the scientific arena. Professor RS Nickerson of Tufts University notes that much of the literature on creativity is speculative. Similarly, Richard E Mayer of the Department of Psychology at the University of California, Santa Barbara, confesses, in *'Handbook of Creativity'*, that students of creativity "are sometimes confronted by speculation that is only loosely related to empirical data".

Sensitive to this backdrop, I envisaged the need to explore creativity in a novel, yet systematic way, involving data gathering and analysis. I wanted to attempt to widen the understanding of the motives underlying creative minds and practices, in the hope of discovering patterns that could frame a new paradigm of creativity for the new millennium.

This book explores the genius behind some of the world's most creative people. They were invited to express the roots of their creative drive, by answering the question *'Why Are You Creative?'* through interviews and/or verbal or graphic representation. Their answers are accompanied by brief biographies and then are analyzed or 'deconstructed' by Dr Jeffrey Zeig, founder and President of the Milton Erickson Foundation of Psychiatry, and a panel of psychologists. In the letter part of the book I attempt to identify the crucial motivational factors underlying their creativity.

HOW THE WHY IS FRAMED

Although not strictly scientific, the study's method has some claim to uniqueness, and has been ingeniously constructed to meet the complexities of the topic. The samples have been taken from a broad spectrum of creative disciplines including advertising, filmmaking, photography, graphic design, literature, music, and politics. I interviewed fifty-five of the world's creative luminaries, people whose status and reputation as creators is unquestioned. The sample therefore constitutes a persuasive corpus of reliable source material.

In addition to face-to-face interviews, the multi-method data collection included a literature search for biographical information, in order to provide context for responses.

During the interviews, it became clear that the conventional Q&A techniques could be too rigid for the creative minds of artists and might limit the scope of their responses. To overcome this, respondents were asked to explain why they are creative graphically and/or verbally - on a piece of paper. This would allow them to go beyond the common facades to divulge the secrets and stimuli of creativity. As Dr Zeig has said: "Graphics cover a three-dimensional depth that is unattainable in two dimensional ways."

The method of data analysis is also unique. Here the conventional narrative techniques of a descriptive, interpretative analysis are combined with the hermeneutical method. Dr Zeig and the panel of psychoanalysts were employed to unearth the underlying motives of the respondents. It is possible that there will be those who deem the use of psychoanalysis as lacking sufficient scientific method to constitute a serious exposition of the subject matter. Although it is probably true that my research could have been more rigorous and scientific, I believe that my method has considerable validity, despite its unusual genesis. But the beauty, and significance of this study lies in its creative methodology rather than its conclusions.

DEFINING CREATIVITY

Creativity, once a divine gift and metaphor for elite intelligence, is now available as a bargain-basement come-on for supermarket chains. Bookstores are riding this bandwagon. From creative painting or creative hiking to creative divorce anything goes if it 'creates' sales. Even a mixed salad at your neighborhood steakhouse becomes a creative salad. This fact seems to have hit a raw nerve for furious Benetton photographer Oliviero Toscani who dismisses our unworthy efforts thus: "Only God can create."

This surprisingly medieval view is rooted in the 'Divine Intervention' school of thought, where creativity is a result of the invocation of the The Muse. Definitions of creativity have been broadened more recently. The word creativity comes from the Latin word 'creare' meaning to 'bring something into being that did not previously exist'. Webster's dictionary defines creativity as being: "Marked by the ability or power to create; having the quality of something created rather than imitated."

In the *'Handbook of Creativity'*, we find that Richard E Mayer brings together several definitions of creativity. For example, Howard E Gruber and Doris Wallace contend that the creative product must be new and must be given value according to some external criteria, while Colin Martindale believes that a creative idea is one that is both original and appropriate for the situation in which it occurs. Charles J Lumsden, in his summary of creativity in literature, says it involves the capacity to think up something new that people find significant. Gregory J Feist, on the other hand, notes that psychologists and philosophers who study the creative process, creative people and their output, are in consensus about creativity in that it produces novel and adaptive solutions to problems.

Others, such as Todd I Lubart, who say that creativity can be defined, from a Western perspective, as the ability to produce work which is novel and appropriate.

While not everyone considers it possible to articulate precise objective criteria for the identification of creative products, novelty is often cited as one of their distinctive characteristics, and some form of utility – usefulness, appropriateness or social value – as another.

From these definitions we can conclude that the two defining characteristics of creativity are originality and usefulness.

It is worth comparing these definitions with those given by some of the creative people who participated in my study.

Film director Joe Pytka echoes Oliviero Toscani's comments with: "Creativity and ideas come from God, whether you are a Protestant, a Hindu, a Catholic or a Jew, there is some metaphysical force out there." Pytka sees his own creativity in defending ideas from corruption. Creativity is a transcendental discovery. For the writer Gabriel Garcia Marquez, loneliness is the condition for creativity, because he believes writing is the loneliest thing in the world.

The great English director, Paul Arden, explains: "Be different. If you are not different in your own creativity, you do not get recognised and everything else is academic."

Michael Conrad believes that in finding creative solutions: "You have to know the rules to break them." John Hegarty agrees, saying: "When everybody zigs, I zag." And George Lois says: "If everybody runs in one direction, I run in the other and go anti-trend." Finally New York Art Director Helmut Krone in the eternal quest for creativity: "I'm not interested in beauty, I'm not interested in craftsmanship, the only thing I'm interested in is NEW."

However complex and unfathomable, it appears that there is a consensus among respondents that creativity means non-conformity, originality. This ties in well with Mayer's findings.

However, Mayer notes in the 'Handbook of Creativity' that, despite the consensus in defining creativity, many "basic clarifying issues such as whether creativity refers to a product, process or person, whether creativity is personal or social, whether creativity is common or rare, whether creativity is domain-general or domain-specific, and whether creativity is quantitative or qualitative" are not resolved yet. He further emphasises the need to focus research in these issues.

In this study I take the perspective that creativity is a property of the individual and limit the scope of the study to discuss one fundamental issue: What are a creative person's unique stimuli?

CATEGORIES OF CREATIVE STIMULI by Hermann Vaske

In order to investigate the stimuli in the creative process, I combined evidence from respondents' biographies, interviews and expressions and examined this data under the psychoanalytic spotlight. The findings indicated ten fundamental categories of stimuli. It is essential to recognize that the edges of these patterns are frequently blurred, often overlapping, and often academic. But, for the sake of clarity, they are discussed separately.

1. EXTRINSIC MOTIVES

This category includes comments which seek external sources as a motive for creation.

According to Freud, writers and artists produce creative work as a way to express their unconscious wishes in a publicly acceptable fashion. PE Vernon defines unconscious wishes as power, riches, fame, honor or love, things that money can buy, and which are perhaps the lowest common denominator of creativity.

The comments from my respondents which fall into this category mainly focused on the motivational power of money. For example Jaques Séguéla said: "Money has no idea, only ideas make money." Similarly playwright and director David Mamet, in response to the question *'Why Are You Creative?'*, said: "I have always attempted to avoid starving to death".

Marc Twain held that money was the only sensible reason for writing. Few of these respondents would disagree.

2. INDIVIDUALITY AS A CREATIVE EXPERIENCE

Collins Dictionary describes individuality as a distinctive or unique character or personality, "a quality that distinguishes one person or [thing] from another." The contributions in this category can be read as a works of great individuality. As Nelson Mandela said in his answer "There are many creative individuals - men and women - who have distinguished themselves in this regard."

It is often said that people's creativity is a pure expression of their personality. Preserving individual differences is beneficial to one's creativity.

The first advice given to all young creative people is: "Be different." All the contributors who see their creativity as an expression of their individuality [consciously or unconsciously] seem to accept this. They let us experience their creativity as a part of their individuality.

Keith Reinhard is rebelling against limitations and conformity. He goes outside the box. Yoko Ono and Gary Oldman express their unique creativity in being at one with themselves as individuals and Sean Penn describes it as a "Big Black Hole in Yellow - Me." Driven by their character's unique motivations, these individuals swim against the tide.

This reminds us of Ralph Waldo Emerson who said: "The more finished the character, the more striking is its individuality." Through their individuality, each creative person becomes a brand of their own, presenting us with a unique identity, their own Unique Selling Proposition.

That is very much in line with what Professor Stephen Hawking said to me "You have to be creative to do science. Otherwise you're just repeating tired old formulas. You aren't doing anything new".

As Dr Zeig says: "Through our creations we discover our identity and define our soul's song."

3. REACTION AGAINST BOREDOM

The contributions in this category reflect on creativity as an antidote to convention and boredom. The range of comments includes: "The alternative is way too boring" from Laurie Anderson; "Because the alternative sucks" from Lee Clow, who drew a suit and a tie as the alternative; and Tony Kaye's statement that creativity is a way of surviving a "fucking average world".

4. PASSION-LOVE-AMBITION-JOY

In this category creativity is seen as an expression of respondents emotions reacting to the theme question. A Freudian, hydraulic conception of emotions as energy seeking release, seeking channeling. Dr Ruth Westheimer says "Out of passion"; Milla Jovovich goes further, and writes "Because I'm hungry" and Joe Pytka threw a basketball onto the layout. Emily Watson states, "For love", while Tony Scott expresses the same thought by drawing a heart. And MA Collins and TM Amabile in the 'Handbook of Creativity' sum it up by saying: "One thing we can conclude with confidence is, that love for one's work is advantageous for creativity."

Marcello Serpa writes "I'm happy." On the other hand, the author Howard Gardner claims, with Mozart in mind, that creative people create all the time independently from the ups and downs of their emotions. But, as writer Jochen Paulus wrote in 'Die Zeit' [19/1999], other research shows that Robert Schumann composed more prolifically when he was on an emotional high [a clear parallel with Marcello Serpa's answer: "I'm happy!"] and significantly less when he was depressed.

Mika Häkkinen offers proof that he is driven by ambition. Häkkinen writes in his native Finnish "the will to win."

GJ Feist, writing in the 'Handbook of Creativity', discusses the following as a stimulus for creativity: drive, ambition, self-confidence, openness to experience, flexibility of thought and active imagination.

5. ANXIETY

These contributions reflected on angst and fear as sources of ignition for the creative process. One response, from creative director Mike Tesch, was: "Fear – that I wind up being a dentist." This reminds me of a conversation I had with director Jon Amiel who said: "When I stop doing projects which I am afraid of, I am no longer creative."

"You're always afraid of the darkness. We're all afraid of what we don't know", a Marine Corps Instructor once told Harvey Keitel. "And in all the reading I've done," Keitel concluded, "and all mythology I've read, and all the religious writing I've read, the darkness is the one place they all have in common - that we must enter into."

The great surrealist David Lynch reveals his fear creatively in his journey into the darkness. In the heart of darkness he draws a question mark.

Creativity is seen as a chance to defeat fear and ultimately death. For example, Stein Leikanger addresses the idea that, creativity can achieve permanence in the face of death, that the creation can outlive the creator.

Into this pattern falls also the unconscious hope, that the creators can survive their creations, just as the creations may survive the creators. Bearing in mind the creation of eternal values, it is not surprising, that in response to my 'Why Are You Creative?' question, creative director Jeff Goodby once said to me: "To cheat death." Creative people from the Far East seemed to have come to terms with the anxiety that surrounds death and creativity. I like to single out Takeshi Kitano who said: "The highest form of creativity for me is death. Creating things is like the process of dying." As Dr Zeig sums it up: "There is no antidote to death, only the possibility of creatively living life to the fullest."

6. COMPULSION-DESTINY

The category includes those respondents whose desire to create is all encompassing, those who cannot stop. They are 'creataholics', addicted to the creative impulse. Many respondents were driven by these motives, offering comments such as: "We can't help it. Creativity is our life." [Christo and Jeanne-Claude], "I don't act to make a living, I act to live" [Ben Kingsley]; "Because I don't seem to have a choice in the matter." [Salman Rushdie]; "Because I have to." [Günter Grass]. "I was desperate and lonely. There seemed to be no way out." [Dennis Hopper]. And finally Frank Gehry who wrote, "There is nothing else to do."

7. HERITAGE-PARENTS

In response to the 'Why Are You Creative?' question, Tony Kaye cuts himself and spurts his blood on a piece of paper, while Steven Spielberg comments: "I was born that way, because of my father and my mother." Those responses are representative of many contributions which link creativity to the genetic code of their parents.

8. SPIRITUALITY-METAPHYSICAL

This pattern emerged out of respondents' contributions which linked the metaphysical and spiritual forces to their own creativity. Such a link could be seen very clearly in comments such as "Creativity comes from God, from heaven, from the ether" [Leni Riefenstahl], or "Creativity is a gift to me by God" [Quentin Tarantino]. An interesting observation comes from the film director Joe Pytka who says "Creativity and ideas come from God, whether you are a Protestant, a Hindu, a Catholic or a Jew. There is some metaphysical force out there." Pytka sees his own creativity in defending ideas from corruption. Similarly, Bono's expression that he's creative because he has a God-shaped hole, drawing the rings of eternity inside the 'O'.

This pattern reflects earlier accounts of creativity as being a consequence of divine intervention. According to this theory, the creative person is seen to be an empty vessel which is filled with inspiration at the whim of a divine being, through the medium of a "muse". This, the fortunate person would then use this divine inspiration to create a worldly product. Even today, people still speak of waiting for their "muse". This reminds us of Sigmund Freud's observation: "Leonardo Da Vinci ... did not lack the divine spark which is directly or indirectly the driving force – il primo motore – behind all human activity." [Sigmund Freud, Art and Literature]

9. SEXUALITY-LIBIDO

Freud explains that the sublimation of primitive drives is a creative force. Within primitive passion there is a font of potential creative energy. Many contributions in this study support this thought. In response to the study's question, Kitano said: "Because I have a big cannon", and drew a man with a big penis, while Araki suggested: "Because everywhere, at all times, I have an erection" and drew a multiphallic elephant.

10. REGRESSION

By 'regression' I refer to those respondents whose contributions indicate that they are creative because they are capable of going back in time to their childhood and of seeing the world with a childlike naiveté.

An example which puts it together is Wenders' contribution: he drew a Teddy bear with the word 'BECAUSE' on a sign around it's neck. According to him ,"Children are all creative and it is a question of how much one stays in touch with it." I would like to sum up this pattern with a quotation from Schopenhauer: "A great poet ... is a man who, in his waking state, is able to do what the rest of us do in our dreams."

A deeper analysis of all these patterns has important bearing on the continuing debate over whether creativity is rare, in that it belongs to a selected few, or if creativity is commonplace in that it belongs to us all. There was support for both sides of the argument among the participants. The comments of those who believe creativity is rare could be summarized in Quincy Jones remark: "Because God gave me music". There is a wide base of literary support for this argument. On the other hand, many respondents argued that creativity is common. As Dave Trott sums it up: "Everybody is creative. The difference between the so called creative people and the so called non-creative people is, that creative people do it." The findings of the study and the literature indicate a balance of support for both sides of the argument.

LAURIE ANDERSON multimedia & performing artist

Born into a musical family in 1947, Laurie Anderson was raised near Chicago. She studied violin, and moved to New York to earn a degree in Art History at Barnard College in 1969. In 1972 she earned an MFA in Sculpture from Columbia University and began to perform 'installation pieces', and combined exhibitions and events in small art galleries, museums and postmodern dance spaces.

Later, her installations became less important than her recordings, which reached a much wider audience.

Selections of her work were included on two significant albums in the 1970s: 'Airwaves' and 'New Music for Electronic and Recorded Material'. Her song 'O superman' became a surprise Number One hit in Great Britain in the early 1980s.

Much of her work, such as her massive multi-media spectacular 'United States I-IV' [1979-1984], combines minimalist music with overwhelming visual spectacle, and is often compared to opera. Lately she has been instrumental in popularizing mixed-media, and making technology more accessible through her records and MTV appearances. In August 2001 her new record 'Laurie Anderson: Life on A String' was released.

ANDERSON I like to pretend that I'm being creative when I'm lying on the beach ... the real truth is I have no idea how to take a vacation. I'm very, very bad at it. I like to work so shoot me. That's just what I like to do.

VASKE And why are you creative?

ANDERSON And why? It makes me laugh ... it's really simple: it just makes me laugh, it makes me feel like I can change things ... like I can change things.

 PHOTO Guido Harar / Contrasto / Focus

1) THE ALTERNATIVE
IS WAY TOO BORING

2) I LIKE TO BREAK RULES

3) I LIKE TO LAUGH.

und so weiter

DECONSTRUCTING
LAURIE ANDERSON

Dr Zeig comments: "When Thomas Edison was asked by an assistant to specify what laboratory rules needed to be observed, he replied 'Hell, there ain't no rules around here! We are trying to accomplish something!'" He goes on: "Disturbing the equilibrium is not bad. Homeostasis does not breed creativity. Homeostasis does not breed humour. As Max Beerbohm noted, incongruity is the meaning of laughter. A momentary destabilisation precedes the laughter of a joke, and the laughter itself resolves the preceding tension and drama."

Laurie Anderson surprises people all around the world with her performances. By creating laughter [in herself as well as others] she reveals the truth, and provides an antidote to boredom. I leave it to Arthur Koestler to conclude: "Humor," he wrote in his book 'The Act of Creation', "is the only domain of creative activity where a stimulus on a high level of complexity produces a massive and sharply defined response on the level of physiological reflexes."

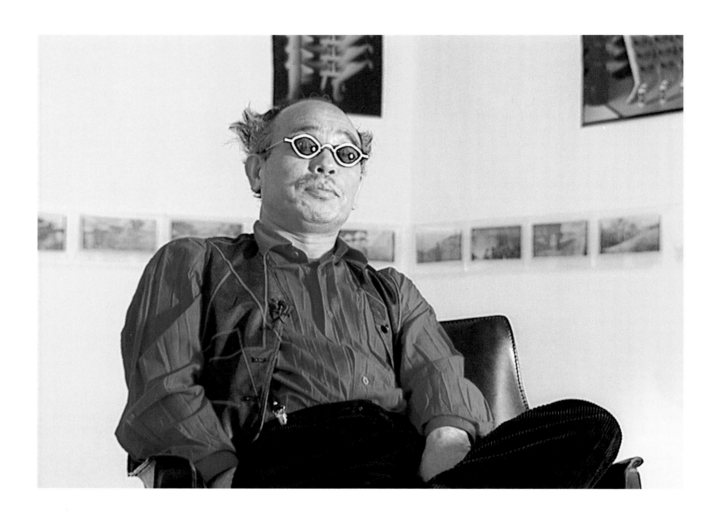

NOBUYOSHI ARAKI photographer

Born in 1940 in Tokyo, Nobuyoshi Araki studied photo-
graphy and film-making at Chiba University [1959-63].
He has had more than eighty one-man shows all over the
world, and has published over a hundred books.

His first major publication was a photographic diary
'Sentimental Journey' describing his honeymoon with Yoko,
his young bride. Focusing on their shared erotic experiences,
the book boldly presented their intimate
secrets to the public.

Tragically, in 1990, Yoko died, and Araki
attempted to give expression to his sorrow
and pain in a number of exhibitions. His wife's
death forced Araki to deal with the grue-
some facts of death. His photographs
combined the violent reality of Yoko's death and the
city of Tokyo, with fantasies bordering on the perverse, and
pictures of his cat Chiro.

Araki's photographs belong both to the Japanese tradition
of personal novels [which seek their themes in the realm of
highly intimate detail] and the age-old tradition of Japanese
eroticism. His work has appeared everywhere from literary
and philosophical journals, and in popular magazines, to
pornography, to stations, cafes, department stores, and
the most distinguished museums and Art Centers around
the world.

VASKE Why are you creative?

ARAKI Creative? Why creative? What me, creative? I doubt it.

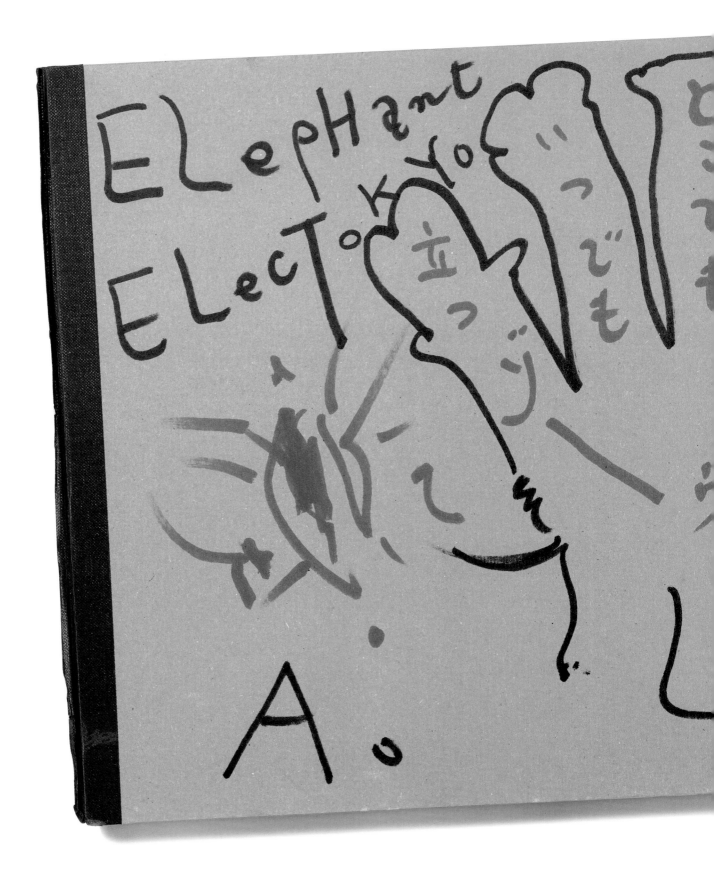

DECONSTRUCTING NOBUYOSHI ARAKI

Freud said everything was down to sex, and in Araki we see the proof. "Everywhere, at all times, I have an erection," Araki-San writes in Japanese on the phallic protrusions of the surreal multiphallic, elephant facing an open vagina, he has drawn. Dr Zeig comments: "The English, I assume, is meant to be 'Elephant ErecTokyo', not 'Elephant ElecTokyo'. Araki-san does not leave much to deconstruct. A Scandinavian poet noted that everything being concave or convex, it all reminds us of sex. Obviously, Araki has been fixated in his elephant stage of psychosocial development, a stage of which Freud was oblivious. Araki-san would heartily agree with Woody Allen who described the brain as his "second favorite organ." Freud had a theory that the source of much creative activity is the frustrated sexual impulse. Araki is unusual in that no sublimation takes place; what you see is what you get.

DANIEL BARENBOIM conductor

Daniel Barenboim was born in Buenos Aires. In August 1950, when he was only seven years old, he gave his first public concert in Buenos Aires.

Following his début as a conductor with the New Philharmonia Orchestra in London in 1967, Mr. Barenboim was in demand with all the leading European and American symphony orchestras.

Between 1975 and 1989 he was Music Director of the Orchestre de Paris, his tenure marked by a commitment to contemporary music.

Daniel Barenboim has always been active as a chamber musician, performing with, among others, his late wife, cellist Jacqueline du Pré, as well as with Gregor Piatigorsky, Itzhak Perlman and Pinchas Zukerman.

In 1991, he succeeded Sir Georg Solti as Music Director of the Chicago Symphony Orchestra with which he has since enjoyed countless successes in all the world's great concert halls. In 1992 he became General Music Director of the Deutsche Staatsoper Berlin. He currently holds both posts.

VASKE Mr. Barenboim, why are you creative?

BARENBOIM Most probably because I can't be anything else. That means every day when I wake up I want to create something, it is very important for me to have new ideas, to rework old ideas and to transfer what I have learned in one discipline into the other discipline.

VASKE Where do you get your creative stimulus from?

BARENBOIM I am a very curious human being and curiousity is probably one of my most noticeable character traits, if one is curious than one is willing to learn and one waits to find out about things. If one does not have curiousity, then one falls very quickly into a passive role.

VASKE Can creativity help solving the problems of the world?

BARENBOIM To solve the problems of the world one has to be creative and find creative solutions. Creativity in the artistic sense cannot solve the problems in the world, but it can lead from chaos into order and discipline. Only from the dark you can see the light and that is the only way to see it these days.

PHOTO Volker Hinz

Because I am a very curious person and curiosity is necessary as the first step towards learning about ourselves and about the world.

Daniel Barenboim

DECONSTRUCTING
DANIEL BARENBOIM

"Barenboim", says Dr Zeig, "is very meticulous and rational in his reply. He is linear and moves in directed steps. His intellectual part is his guide. His curiosity opens doors. Subsequent steps are directed from his head."

Dr Henkel adds: "Barenboim is right. Curiosity is a very important component in our development, not just in the development from infant to child to adult, but also in the development of our species. Consequently, he is open to experimentation - a nonconformist, willing to take some risks in exploring new boundaries and frontiers. He is imaginative and idea-oriented and by this means open to change. Besides, where would curiosity lead if not to change?"

JULIETTE BINOCHE actress

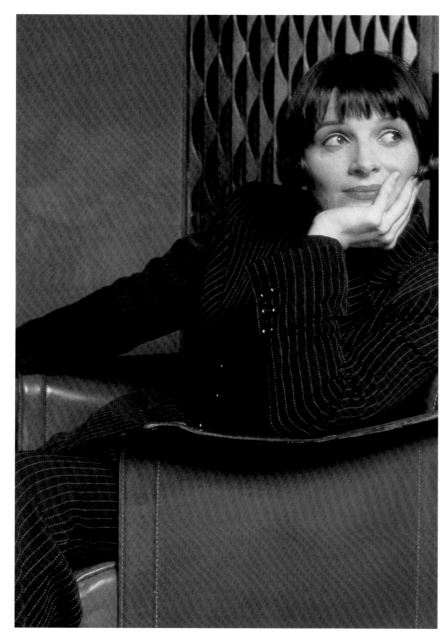

Juliette Binoche was born in Paris in 1964 into an artistic family. Her mother was an actress, and her father a theater director. She developed an interest in the theater in her school years and took lessons at the Conservatoire de Paris. On leaving school she worked in the theater and supported herself as a cashier in a store. Her film career began in 1982 when Jean Luc Godard wrote a part for her in his *'Je Vous Salue, Marie'*.

BINOCHE I learned that a movie can be a work of art, like a secret, a poem whispered softly.

She then completed her acting education by taking many small parts working with some of the greats of French cinema such as Jean-Luc Godard, Jacques Doillon and Dominique Besnehard.
After roles in movies like *'Les Amants de Pont-Neuf'* and *'Wuthering Heights'* Juliette received the Cesar prize in 1994 for *'Trois Coleurs: Bleu'*.
In 1997 Juliette won an Oscar as Best Supporting Actress in *'The English Patient'* and was nominated for another Oscar as Best Female Actress in *'Chocolat'* in 2001.

DECONSTRUCTING JULIETTE BINOCHE

Binoche's answer translates
as "to join the high and the low."
Dr Zeig sees in her answer a
novel twist – creativity as the
Prozac of the soul.
Freud declared that psychoanalysis
freed the patient from neuroses
so that they could struggle with
the vicissitudes of life. Creativity,
in this analysis can balance good
and bad fortune. Creativity, though,
is neither medication nor therapy,
but can serve as a fulcrum, as
a point of balance.

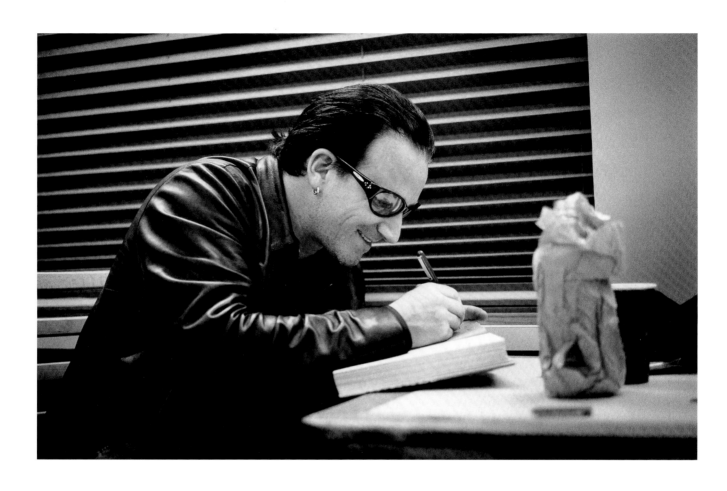

PHOTO Donata Wenders

Bono was born Paul Hewson on 10 May, 1960. He grew up in Dublin with a Protestant mother and a Catholic father, a union that led to his inspired life.

In 1978, he joined his first band 'Feedback' with more on the strength of his charisma than his ability to sing or play an instrument. And he never looked back.

Bono became famous as the front-man for the super-group U2, for a lot of critics the most important rock band in the world. U2 began their career in 1980 with 'Boy', which went down well with *Rolling Stone* magazine, but was not a commercial success.

But in 1983, U2 released 'War', an album filled with passionate, angry anthems which went platinum. It also broke through to America. Four years later, the multi-platinum 'Joshua Tree' won the Grammy for best album and a spot on the cover of *Time* magazine, confirming U2's super-group status.

At the Brit Awards in 1999 Bono asked people to help the Jubilee 2000 campaign, an initiative to cancel the Third World Debt by the year 2000. The goal was to gather as many signatures as possible for this petition, and to give the people in developing countries a life worth living for the new Millennium.

Bono has also collaborated with Wim Wenders as one of the producers of his feature film *'Million Dollar Hotel'*, which is based on a story by Bono and Nicholas Klein. In 2000, U2 released 'All That You Can't Leave Behind', followed by an extremely successful world tour in 2001.

VASKE Why are you creative?

BONO Why are you creative? Well, there's different combinations of creativity. You know, it depends on the combination and to be in a band requires a lot of very different skills... Why am I creative? Well, isn't art an attempt to identify yourself also? And I think that's probably it. I think coming from the culture that I came from, neither being Catholic or Protestant, lower ... working class or middle class, the ability to see a lot of different points of view is a bit of a curse and that can play havoc with you. I mean U2's work at the moment is about identity crisis. That's its very subject so I have to believe that's what it is. That's what's turning us on right now.

VASKE What do you mean by that?

BONO Well ... maybe moments that are really spiritual or meditative.

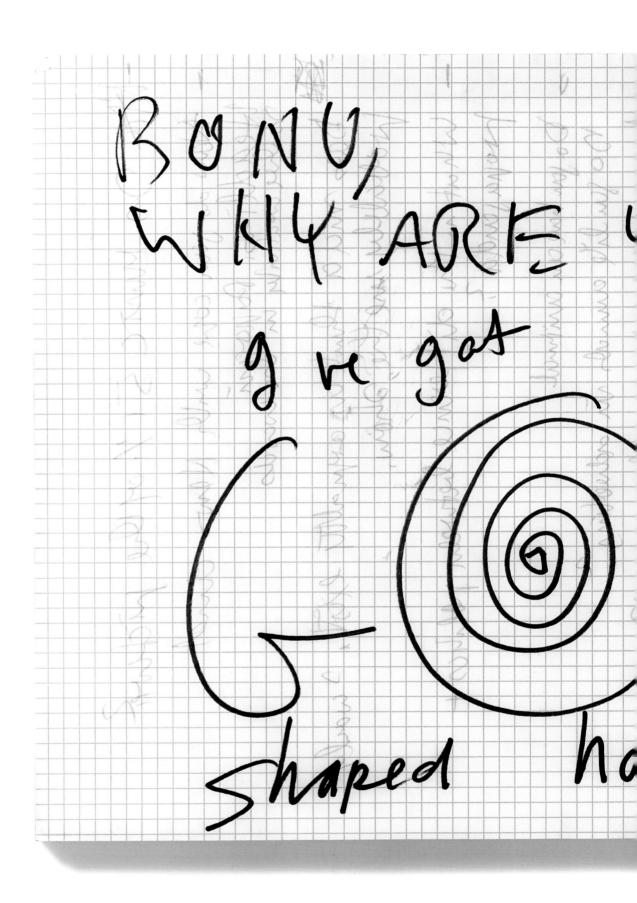

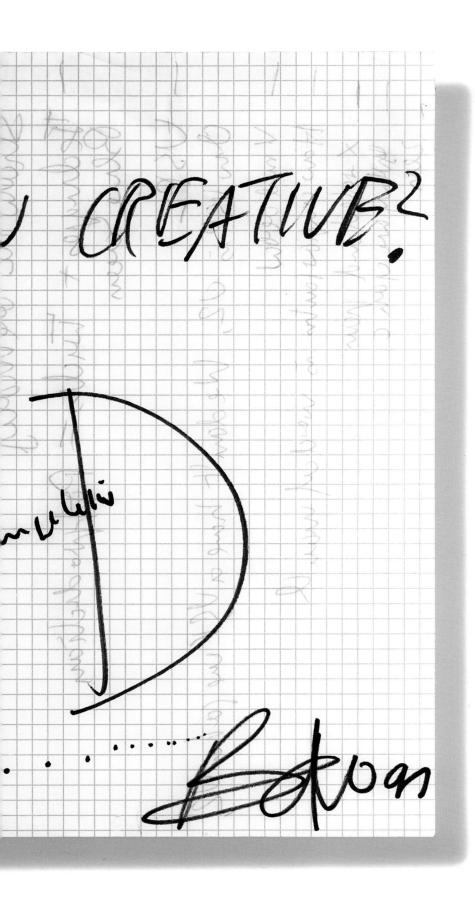

DECONSTRUCTING BONO

Creativity is transcendent discovery. Dr Zeig says: "A hole begs to be filled. An infinite hole can never be filled. A spirit-sustaining creativity might not fill the hole, but it's a start." Bono's contribution is seen by Dr Zeig as "mysterious and unique, forming a deeper goal."

Bono's quest for a deeper goal – spirituality and purpose – is not only reflected in his response to the question "Why are you creative?" but also in the U2 song *"I still haven't found what I'm looking for."*

Bono is on a quest for self-discovery and spirituality.

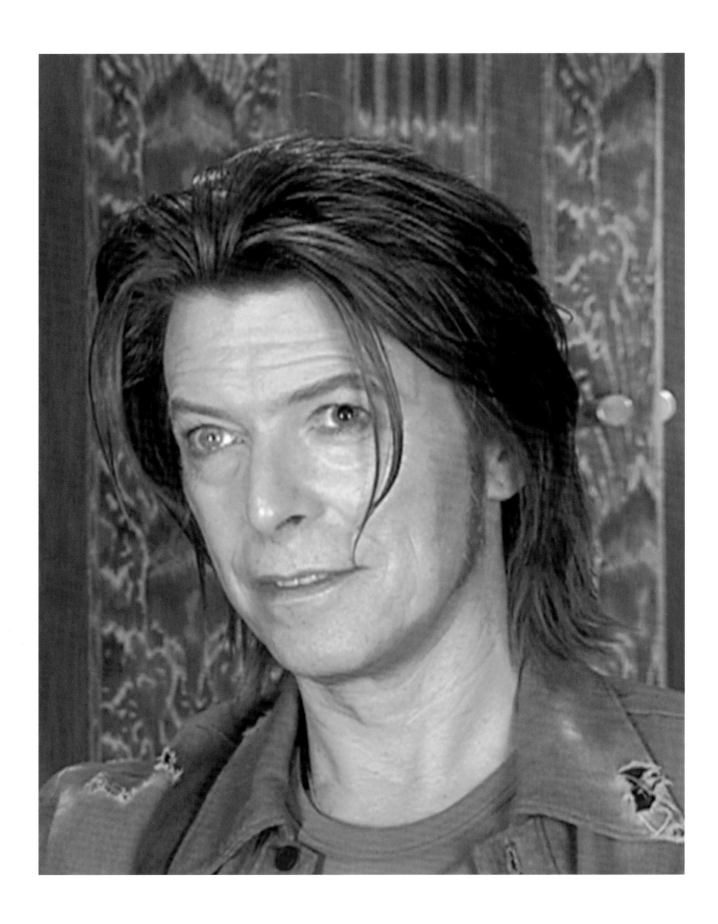

DAVID BOWIE musician, artist & actor

Born David Jones in 1947 in Brixton, England, Bowie's musical career started in the 1960s, with his first international success, *'Space Oddity'* coming during his Major Tom incarnation. His constant re-invention continued in the seventies and eighties in the guises of 'Aladdin Sane', via 'Ziggy Stardust' to 'The Thin White Duke'.

The eighties also saw him become a true crossover artist, adding acting to his long list of successes, appearing in *'Schöner Gigolo, armer Gigolo'* and a theatre performance of the *'Elephant Man'*. He also played a vampire in *'The Hunger'* and a soldier in *'Merry Christmas, Mr. Lawrence'*. He then transformed himself again, becoming a post-modern yuppie, and creating his massively successful hits *'Let's Dance'*, *'China Girl'* and *'Modern Love'*.

He then went through a minimalist period with his band 'Tin Machine' and started to develop his obsessions with art and painting.

After many successful art shows in galleries all over the world he released 'Outside', an avant-garde music album toying with shock art. 1997 saw the release of 'Earthling'. His next ground-breaking step was to go public on the New York Stock exchange with a rating higher than several banks.

In 1999 David Bowie received an honorary doctorate in music from the Berkeley College of Music in Boston. Always ahead of his time, Bowie also launched Bowie Net in 1999, thus introducing the world to the first artist-created internet portal. Soon after he released 'Hours' which became one of the celebrated albums at the turn of Millennium.

VASKE Why are you creative, David?

BOWIE Um, I think it has something to do with wanting to find a place where I can kinda set sail and know that ... I won't really fall off the edge of the world when I get to the end of the sea, that there'll be just more and more sea to navigate. There's the idea that in sort of being creative it's one of the few human endeavours that you can get involved in where you can, as Eno would say, crash your aeroplane and walk away from it.

I think it's a sort of intellectual field of adventure, and it can either be play or it can be war, or maybe a hybrid of both.

And I find it an intoxicating parallel to my perceived reality to be able to have this other one, where you can explore anxieties and fears.

DECONSTRUCTING
DAVID BOWIE

Dr Zeig comments: "David Bowie presents a way of coming off the page. He creates the experience of depth. Creativity often is a way of making things three-dimensional, things that were previously two-dimensional."

The three-dimensional contribution reflects on Bowie as a more dimensional artist. For Bowie anything goes. Bowie takes from the post-modern lemon tree of high and low culture, the perfect example of cross-over.

The Berlin psychotherapist Dr Ju Tapkin agrees, commenting that: "The hole suggests a break-through (of the frame in this instance) that allows Bowie to go into space and cross boundaries." And indeed no-one has re-invented themselves artistically, so successfully as he.

Bearing that in mind it is no surprise that he answered the question artistically.

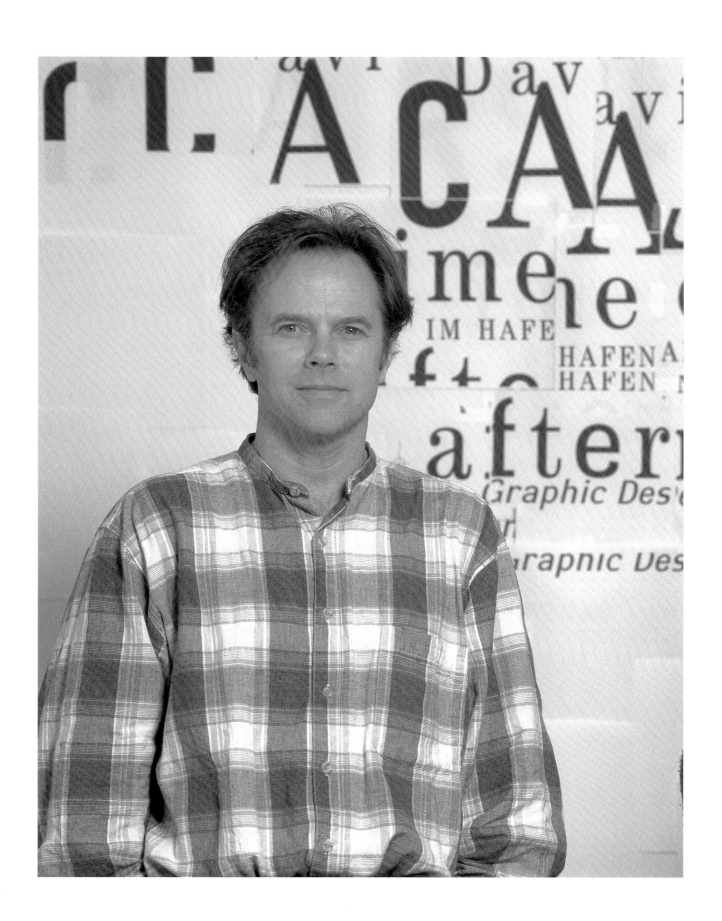

PHOTO Elger Denis Esser

DAVID CARSON graphic designer

Born in California in 1956, Carson spent his early years as a professional surfer and teacher before entering the world of graphic design. Exposure to the avant-garde and deconstructivist styles in Europe led him to develop his own unique approach towards graphic design.

Returning to California, he art-directed skateboard and surf magazines, deconstructing pictures of beach culture. He then became the Art Director of *'Ray Gun'*, a music magazine. Through his punk and Dada Art Direction he made the magazine a huge success, creating a seminal new look for Art-Directors all over the world.

Carson did many typographic exhibitions. Amongst others 'Time after Type', 'Graphic Design at the End of Print', initiated by Thomas Rempen in Düsseldorf.

Today Carson works for world brands such as Levis, General Motors and Nike, lending them an extraordinary, rebellious look. He is also the author of a number of influential books on graphic design and typography.

Dr Zeig

said:

"David

Carson's

desire

to

leave

his

creative

legacy

is

the

key

to

his

creativity."

NICK CAVE singer & songwriter

Nick Cave was born in 1957 in Warrack-nabeal, Australia. Cave's first group 'The Birthday Party' achieved some significant early success, before Cave left to form the the post-punk super group 'Bad Seeds' in 1983.

Cave released his first album with the 'Bad Seeds' 'From her to eternity' in 1984. After 'Your Funeral…My Trial' was released in 1986, Cave took a two year break from recording, partially to appear in Wim Wenders' film *'Wings of Desire'*. He returned with *'Tender Prey'* which documented his strongest vocal performance up to that point. As one of the leading figures in alternative rock, Cave was invited to perform on the 1994 edition of the Lollapalooza tour to promote his 'Let Love In' album.

The 1996 release of 'Murder Ballads' with Kylie Minogue, Cave's most commercially successful album to date, was followed by 'The Boatman's Call' in 1997, the 'Best Of' in 1998 and 'No More Shall We Part' in 2001.

VASKE Nick why are you creative?

CAVE It is the only thing that I know how to do properly in my life. Life presents itself with a whole lot of different situations. It presents itself with a lot of different areas that you work in; relationships with people, work, all sorts of different things. The creative side of me works extremely well, it's extremely rich. The rest of my life suffers very much because of my rich creative side. Friendships suffer, relationships suffer, my relationship with my family suffers. Because I have a very rich creative side, and a side that's constantly drawing me to it. And I feel this very strongly. I feel it more and more strongly as time goes on, actually.

 PHOTO Thomas Meyer / Action Press

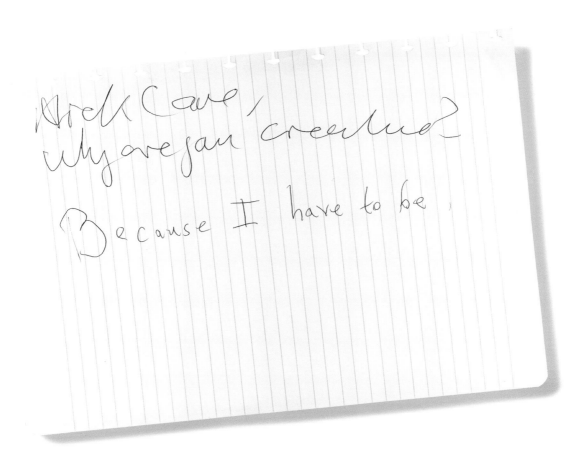

DECONSTRUCTING

NICK CAVE

Dr Zeig comments: "A compulsion can make us do finer things than we are ourselves."

New York psychologist Nicole Henkel adds: "His statement is strong. The force that drives him, his being driven practically jumps at one. He must be this way. There is no stopping. For this man, being creative is the only choice in life, and he has to be so 24 hours a day.

He is very demanding of himself. He does not permit himself to take a break, and keeps going driven, by something inside him. A strong statement like his indicates that this individual is determined and does not waste his time. He has a serious approach to his task."

CHRISTO & JEANNE-CLAUDE artists

Christo was born Christo Javacheff on June 13, 1935 in Gabrovo, Bulgaria.

Jeanne-Claude was born Jeanne-Claude de Guillebon on June 13, 1935 in Casablanca, Morocco.

In Paris, Christo met and married Jeanne-Claude, who became his artistic and business partner.

Christo began wrapping objects for display purposes in Paris in the early '60s. He started with small items, like beer cans and wine bottles, then moved to bicycles, road signs and cars. Christo's projects, known as 'Christos', have grown in size over the years and became much more physically ambitious. Using various kinds of fabric and rope he has wrapped a medieval tower in Spoleto, Italy [1968]; the city hall of Bern, Switzerland [1968]; the Museum of Contemporary Art in Chicago [1969]; and part of the coastline near Sydney, Australia [1969]. He also shrouded some islands in Biscayne Bay, Florida in six-and-a-half million feet of pink fabric, which made an aureole around each of them, floating on the surface of the water. Christo and Jeanne-Claude also wrapped the Pont Neuf [1985], one of the most famous bridges crossing the Seine River in Paris.

Their more recent project, the 'Wrapped Reichstag' in Berlin, is one of the most popular in a long line of wrapped or swathed places or objects.

VASKE Christo and Jeanne-Claude, why are you creative?

CHRISTO It's like asking us, why we are living. Creativity is our life.

JEANNE-CLAUDE All artists are creative. That's the purpose of their life. They cannot help themselves.

CHRISTO Our art has a nomadic quality, it's very nomadic, it's not heavy, it's very sensual and not rooted to some special place.

VASKE Nomads are moving. Is that an inspiration for your work?

CHRISTO Yes, it's the moving, it's the passing through. That feeling is very deeply demonstrated with our temporary works of art.

Jeanne-Claude and Christo
Why are YOU < Reactive ?
We can't help it!
Creativity is
our Life !
Christo and Jeanne-Claude

DECONSTRUCTING

CHRISTO & JEANNE-CLAUDE

Dr Zeig comments: "In the grammar of life, creativity is decisive punctuation. It is the exclamation mark that crafts the mundane into the emphatic. What compels us is the essence of our lives, and the essence of our lives is to create. The fruits of originality are essencial to life. Life is creativity. Creativity is the step beyond, the step that compels us forward in our lives."

LEE CLOW advertising creative

VASKE Why are you creative?

CLOW Because the alternative sucks.

Lee Clow is a member of the One Club Hall of Fame, the Art Directors Hall of Fame and the Museum of Modern Art's Advertising Hall of Fame. Perhaps not surprisingly, he was named the 1997 Creative Executive of the Year by USA Today.

Under his leadership, **TBWA Chiat / Day** has become one of the most innovative agencies in America. In 1997 it was voted Agency of the Year by Adweek, Advertising Age and Shoot magazine [not to mention USA today]. In 1998 it was the same story - named Agency of the Year by Advertising Age and Adweek.

Lee Clow has been involved in some of the world's most talked about campaigns, from Apple's '1984' directed by Ridley Scott and the recent 'Think Different' campaign, to Nike, Levi's, the Energizer Bunny campaign and the Nissan 'Enjoy the Ride' campaign.

R THE ALTERNATIVE.

**DECONSTRUCTING
LEE CLOW**

The drawing on the left is a
self-portrait while the one on
the right represents the con-
ventional suit-and-tie style.
Creativity is at the opposite
pole to tradition.
As Dr Zeig puts it: "Clow's drive
for non-conformity and to break
the tradition is transparent,
it is natural and inevitable."

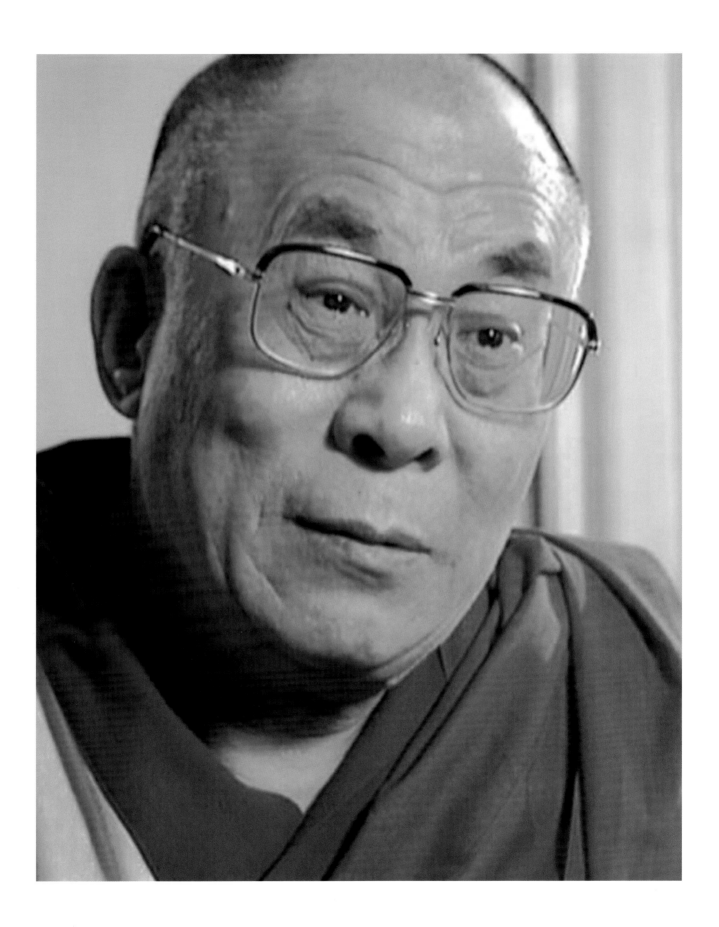

His Holiness the 14th the Dalai Lama Tenzin Gyatso, is the head of state and spiritual leader of the Tibetan people. On November 17, 1950, His Holiness was called upon to assume full political power [head of the State and Government] after some 80,000 Peoples Liberation Army soldiers invaded Tibet. In 1954, he went to Beijing to talk peace with Mao Tse-tung and other Chinese leaders, including Chou Enlai and Deng Xiaoping. After the Tibetan Uprising, which was brutally crushed by the Chinese army, His Holiness escaped to India where he was given political asylum.

In 1963, His Holiness promulgated a democratic constitution, based on Buddhist principles and the Universal Declaration of Human Rights as a model for a future free Tibet.

The Norwegian Nobel Committee's decision to award the 1989 Peace Prize to His Holiness the Dalai Lama won worldwide praise and applause, with the exception of China. The Committee's citation read, "The Committee wants to emphasize the fact that the Dalai Lama in his struggle for the liberation of Tibet consistently has opposed the use of violence. He has instead advocated peaceful solutions based upon tolerance and mutual respect in order to preserve the historical and cultural heritage of his people."

On December 10, 1989, His Holiness accepted the prize on the behalf of oppressed everywhere and all those who struggle for freedom and work for world peace and the people of Tibet. His Holiness often says, "I am just a simple Buddhist monk - no more, nor less."

His Holiness continues to be one of the most influental spiritual leaders of today.

VASKE Can creativity help solving the problems of the world? Especially the Third World?

DALAI LAMA I think that creativity by itself is something neutral: creativity can be destructive; it can be constructive. So, generally, without creativity, there is no further progress. For this progress, of course creativity is very essential. I think because one of the basics for human beings is that we have imagination, and through that we have a creative potential. Because of that the human civilisation, or development, is much greater, or faster, than other species of mammals. But creativity used in the wrong direction with negative motivation creates more disasters. So I feel, creativity can violate human intelligence. But on the other side, with proper values, with warm hearts and a sense of responsibility, a sense of caring one another and also with a broader, more holistic approach, that means, with fully realised side effects of long-term consequences, through that way creativity can become more constructive.

DECONSTRUCTING
DALAI LAMA

The Dalai Lama's answer translates as: "Sentient beings in general and particularly human beings possess great intelligence. Thus positive and negative conceptual thoughts arise ceaselessly. In order to transform the intelligence for a beneficial purpose it is extremely important to possess altruistic attitude and sense of responsibility."

Dr Zeig deconstructs: "From whirling primitive energies, the universe is created with responsible laws. The Dalai Lama understands human consciousness and what it takes to create better human beings. Freud tabbed the alchemy of transmuting basic forces into substance sublimation." Sublimation is the opposite of neurosis. It is the creative path. The Dalai Lama is creative by virtue of his spiritual point of view that transcends individuals and places them in a social context."

Dr Henkel adds:

"The calligraphy is a beautiful and exquisite example of craftsmanship, patience and sensitivity. The strokes are carefully, artfully placed without hesitation or anxiety, demonstrating His Holiness' self-reliance. In his answer, he includes all human beings, thus pointing out that he is attentive to others, does not place himself above anybody else, and that it lies within each and every one of us to be creative."

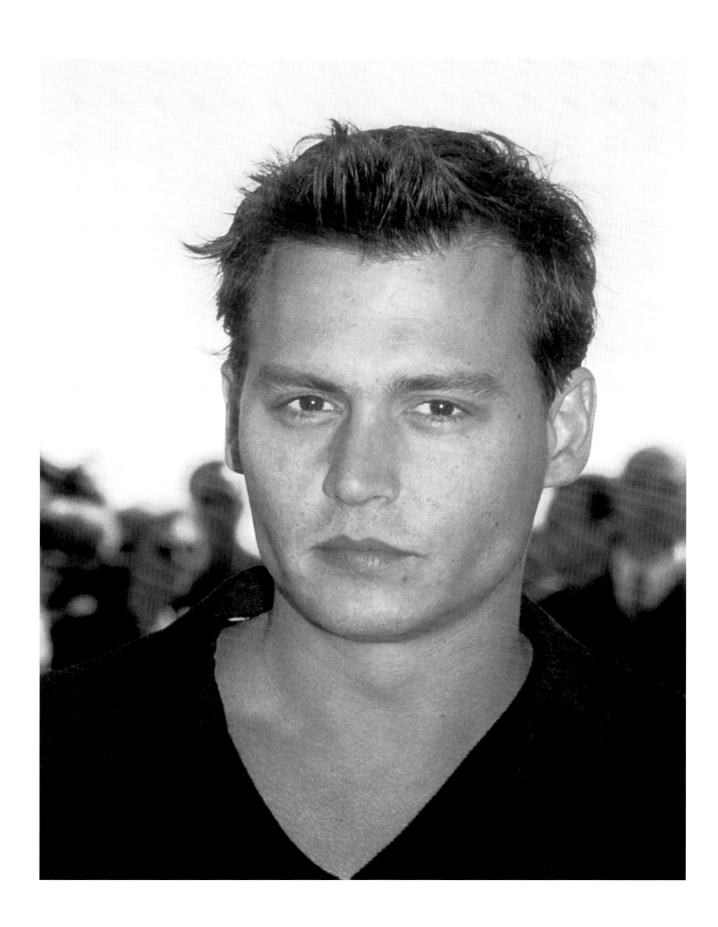

Johnny Depp was born in Kentucky in 1963, and moved to Florida as a child. There he dropped out of school to concentrate on his music, playing guitar in a group that once opened for Iggy Pop.

Johnny got his lucky break when he was introduced to Nicholas Cage who, sensing a fellow spirit, encouraged him to try out as an actor.

His first audition was in Wes Craven's *'A Nightmare on Elm Street'* where he was eaten by a bed. But his career had begun.

After a couple of other small movies, Johnny landed a role in a TV show *'21 Jump Street'* which soon brought him teen-idol status.

With a series of odd roles in films such as *'Who's Eating Gilbert Grape?'* Johnny soon gained the acclaim of critics and fellow actors. He has been nominated for three Golden Globe awards for his performances in *'Edward Scissorhands'*, *'Ben and Joon'* and *'Ed Wood'*.

His performance in *'Dead Man'* was hailed by critics all around the world. The film, directed by Jim Jarmusch, won the Felix Award at the European Film Academy.

2001 was a very productive year for Depp. He delivered outstanding performances in *'Chocolat'*, *'Blow'* and *'From Hell'*, opposite Heather Graham.

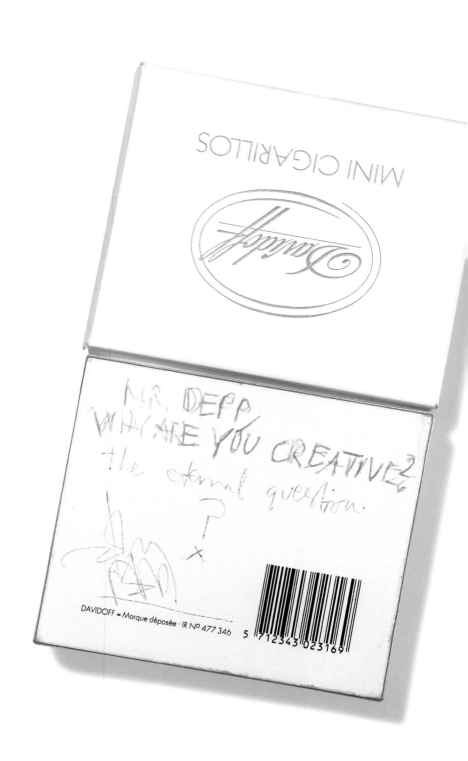

DECONSTRUCTING
JOHNNY DEPP

Henkel deconstructs: "Philosopher
or dreamer? This is the question.
His answer is posed as a question
and statement at the same time.
This man is very good with words
and rhetoric, which may lead one
to think of him as philosopher. But
is he a real philosopher? Or just a
bar-room philosopher – the hip and
cool twentieth century kind of guy
who lives in a world made of dreams
rather than reality.
He comes across as being intellec-
tual, relaxed and patient. He is
almost like a new generation of
romantics. The fact that he uses
the symbol he does reminds one of
a trademark. This symbol certainly
doesn't represent the norm. It is
the symbol that differentiates him
from others, and allows only those
who know into the secret society
they share."

PETER GABRIEL musician

Peter Gabriel has earned a worldwide reputation for his innovative work as a musician, writer and video maker.

When at school he co-founded the group Genesis, which he left in 1975. His albums, live performance and videos since then have won him a succession of awards.

In 1980 he collected a group of people together to found WOMAD [World of Music, Arts and Dance].

Gabriel has released ten solo albums and in 1986, his album 'So' won him his first Grammy. The videos from this project confirmed him as a leader in video production and included 'Sledgehammer', which has won the most music video awards ever.

In addition, Gabriel has been involved in a wide spectrum of human rights and environmental issues. His song 'Biko' was the first pop song which talked about the effects of apartheid, and in 1988 and 1990 he was involved in the Nelson Mandela concerts at Wembley. At the end of 1997 Gabriel was invited by Mark Fisher to help create a show for the central space of the London Millennium Dome. 1998 was spent brainstorming ideas on the narrative and visual concept. In 1999, whilst continuing to be involved with the show's development, Gabriel composed the music. The show was opened on January 1st 2000.

Currently Gabriel is recording his new album 'UP'.

VASKE Why are you so creative?

GABRIEL For me it's an emotional language. So, I think it has a lot to do with childhood. I think is that the idea that artists are these angels that descend from heaven with immense talent, is bullshit. I think, you could give a pill to anyone in the street and tell them in 12 months time they gonna die unless they create some good art. If their survival is really dependant on doing something creative, then they'll find a way to become an artist, whereever they are.

Peter Gabriel,
why are you creative?

Arabella Sheraton
Hotel Derby
Davos

Promenade 139, 7260 Davos Dorf, Schweiz
Telefon: (++41) 081 - 417 95 00, Fax: (++41) 081 - 417 95 95

**DECONSTRUCTING
PETER GABRIEL**

Dr. Zeig deconstructs: "Ascending
from the base earth, heeding an
ascendant calling, one creates.
The simple stick figure can be
fleshed out and can develop form and
substance as it ascends."

FRANK GEHRY architect

Frank Gehry established his architecture firm in 1962. Since then, the practice has grown to a full-service firm with a global roster of celebrated projects, notably museums, theatre, performance, institutional, commercial and residential structures. Raised in Toronto, Frank Gehry moved with his family to Los Angeles in 1947. Mr. Gehry received his bachelor of architecture degree from the University of Southern California, and studied city planning at Harvard University Graduate School of Design.

The most popular of Gehry's extraordinary oeuvre is the universally acclaimed Guggenheim Museum Bilbao, in the heart of Spain's Basque country. Current projects in development include the Experience Music Project in Seattle, Washington; the Bard College Center for the Performing Arts in Annandale-on-Hudson, New York; and the Walt Disney Concert Hall in Los Angeles.

Gehry is the recipient of numerous awards and honors, and he has lectured and taught widely.

VASKE Why are you creative?

GEHRY Luckily I found something I enjoy doing. It's like a disease or a habit - I can't stop it. I really enjoy doing it.

VASKE Does your creativity thrive more on chaos or on discipline?

GEHRY I know my work looks like it thrives on chaos but I think there's a discipline in the chaos. You can't pull off these buildings without discipline. The chaos is the world we live in, so I'm interested in that as context, as inspiration for the work we do.

VASKE How do you get your ideas? How do you get your stimulus?

GEHRY From everything in life around me, that I've seen or witnessed or experienced, you know: paintings, sculptures, the city, the people. I gave a talk in Turkey , and I was asked this question "Where do you get your inspiration?", and I had just been to the capitol of the Hagia Sophia, and I said to the students at the university, that if you looked at that forms in that capitol, there are enough ideas in there for you to last a life time. And I really believe that everything is very rich if you see it that way.

If you look at the space between, if you look at the just accidental pile of books, if I feel like I'm stuck, and I don't know where to move, I just go to a museum and look at paintings, it takes the clouds away, makes everything good.

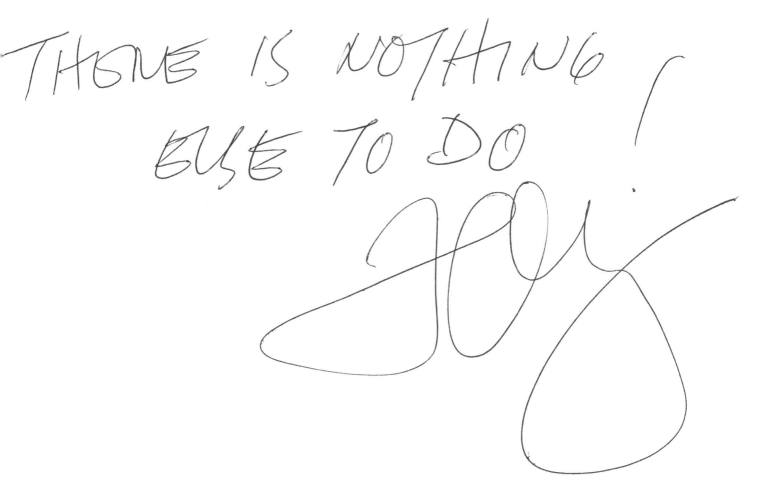

THSIVE IS NOTHING ELSE TO DO

DECONSTRUCTING

FRANK GEHRY

Dr. Henkel deconstructs: "Frank Gehry is making a bold statement, demonstrating a self-assured, straight forward approach to life. This is not a man of great doubts. There is no question that life and creativity are totally enmeshed. For him, creativity is not a separate entity. In his way of answering, Gehry demonstrates that he is an individualistic, self-reliant person who is willing to take risks and to face the consequences."

PHOTO Donata Wenders

Mel Gibson is not only one of the world's most accomplished actors, but also an Oscar-winning director and a respected film-maker.

In the course of his career, he has acted in numerous films, from the extremely successful *'Lethal Weapon'* series to Franco Zeffirelli's *'Hamlet'* and the psychological thriller *'The Conspiracy Theory'*.

He has also found time to produce, direct and star in *'Braveheart'*, the historical action-adventure movie which won five Academy Awards, including Best Picture and Best Director.

Gibson's company, *Icon Productions*, developed and produced *'Braveheart'* and many other movies, including *'Pay-back'*, which stars Gibson. *Icon* is also a production partner in Wim Wenders' *'Million Dollar Hotel'*, in which Gibson plays the role of Detective Skinner. In 2001, Gibson starred in Roland Emmerich's *'The Patriot'* and in the block-buster *'What Women Want'*.

VASKE Why are you creative?

GIBSON Why am I creative? I don't know. I think it keeps me from going insane. I can play. I have an outlet. This is my basket weaving. Weaving a basket is creative. I used to cook, make things to eat for other people's enjoyment. I think all of us have a need to be creative. For some, the drums beat a little louder than for others. But I think everybody needs to be creative in some way. And I think most people are.

VASKE Do you think that basically everybody is creative and that the difference between the so-called creative people and the so-called non-creative people is that the so-called creative people just do it?

GIBSON I think perhaps there is some kind of blockage that stops people from being creative. And that's fine, because it takes all kinds. I have a partner, for instance, and he always says "I take care of the financial stuff and Mel does the creative stuff," but in fact he is the most creative financial person I've ever known – and that is an art. To get the two together is an art. I wouldn't say people are uncreative. I think everyone can be. I think it's part of our make up.

VASKE You mean our genetic make up?

GIBSON Yeah... I think it's right in the DNA. I think that's the right place for it to be.

To stop myse

Mad!

Acting = Ba

from going

t weaving

Dr Zeig comments: "For Gibson
acting can organize chaos. Freud
looked into the human soul and
found a seething cauldron of
impulses he termed the 'Id'.
But still he recognized that one
could delve into that chaos and
unearth creativity."
Henkel adds: "This person is on
a merry-go-round. He is going
and going to prevent himself from
going mad. It's therapy for him.
Releasing his energy into his
chosen direction, he can use it to
his advantage, and be productive.
He needs to be creative all the
time. He refers to acting, one of
his forms of expression, as being
equal to basket-weaving. It's a
nice analogy, which demonstrates
that this man respects his pro-
fession, and sees it as a craft –
as something one always needs
to work on with patience and at
a steady pace, in order to perfect
one's skills."

Mikhail Gorbachev was born in 1931 in Privolnoye in the Northern Caucasus. After working as a machine operator for a while, Mikhail Gorbachev went to Law School and graduated from Moscow State University in 1955. He never worked in his profession, but started his political career in Stavropol, North Caucasus after having joined the Communist Party of the Soviet Union in 1952. His education continued when, in 1967, he entered the Agrarian Institute of Stavropol.

Elected in 1970 to the Central Committee of the Communist Party of the Soviet Union, he moved to Moscow in 1978, to become the new Central Committee Secretary of the Agriculture Department.

In 1984 Gorbachev presented the glasnost and perestroika reformation concepts for the very first time, and moved them forward in his time as General Secretary of the Polit Bureau of the Central Committee of the Communist Party of the Soviet Union [1985 - 1991] and as President of the Soviet Union [1990 - 1991]. His political ascent led to a drastic change within the inner structure of the Soviet Union and to lasting geopolitical change.

Mikhail Gorbachev will go down in history as the man who brought about glasnost, ended the Cold War and paved the way for globalization [and perhaps, one day, global peace]. He revolutionized the world and, in 1990, was awarded the Nobel Peace Prize.

In 2000 he was featured by leading publications of the world as one of the most important people of the Millennium.

VASKE I would like to ask you one provocative question concerning creativity in politics: do you think a politician needs to be creative?

GORBACHEV Deficiency of political leadership comes from the lack of new vision in politics, lack of realisation of what is happening with our world, with all of us, everywhere. That is why politics is lagging behind. But I would not blame politicians for that.

VASKE And how would you define creativity?

GORBACHEV Creativity will be with us as long as we exist.

МИХАИЛ СЕРГЕЕВИЧ
ВАШ ТВОРЧЕСК

Кедюнит Малос

ЧЕМ СОСТОИТ

ОТЕНЦИАЛ ?

DECONSTRUCTING
MIKHAIL GORBACHEV

Translated from Russian, Gorbachev's answer to the *'Why are you creative'* question reads: "Good question, the answer comes later!" Gorbachev has bigger things on his mind than 'Why' he does what he does. He is more concerned with 'How'. His attitude is "Let history judge me."

"The reasonable man adapts himself to the world. The unreasonable man adapts the world to himself. All progress depends on the unreasonable man." – GEORGE BERNARD SHAW

PHOTO Thomas Müller / Focus

Grass was born in Gdansk, Poland [formerly Danzig, Germany], the setting for several of his novels. He was educated at Danzig Volksschule and Gymnasium. In the 1930s he joined the Hitler Youth, and was drafted at the age of 16 and wounded in battle. He was imprisoned in 1945 and released the next year.

After the war Grass studied art at the Academy of Art in Düsseldorf [1948 - 52] and at the State Academy of Fine Arts in Berlin [1953 - 55]. He was also trained as a stone mason and sculptor, and travelled to Italy, France, and Spain.

From 1956, he worked as a sculptor and writer in Paris, eventually settling in West Berlin in 1960.

Grass' extraordinary book, 'The Tin Drum', appeared in 1959 and caused a furor in Germany because of its depiction of the Nazis.

Between 1983 and 1986 he was President of the Berlin Academy of Arts. From 1986 to 1987 he lived in India, writing about it in 'Zunge Zeigen' [1988].

Among Grass' several awards are the Gruppe 47 Prize [1958], German Critics Prize [1960], the French Foreign Book Prize [1962], the Büchner Prize [1965], Fontane Prize [1968], Heuss Prize [1969], Palermo Mondello Prize [1977], the Carl von Ossiezsky Medal [1977], the Viareggio-Versilia Prize [1978], Majakowski Medal [1977], Feltrinelli Prize [1982], and the Leonhard Frank Ring [1988]. Grass also has honorary degrees from three colleges and universities.

In 1989 - 91 he opposed Germany's hasty reunification and, in 1992, he dedicated a public address on the decline of the United Germany's political culture to the Turkish victims of racial violence and murder in the town of Mölln.

In his later essays Grass has also criticized contemporary culture and politics.

Grass was awarded the Nobel Prize for Literature in 1999.

GRASS Art is uncompromising, and life is full of compromise.

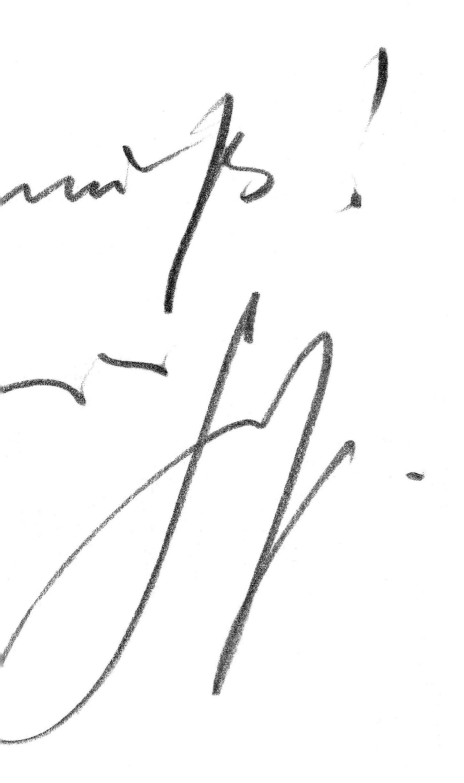

DECONSTRUCTING
GÜNTER GRASS

Translated from German, Grass'
quote reads: "Because I have to."
"It is Günter Grass' destiny to
be creative", comments Dr Zeig.
Günter Grass has no choice. For
him creativity is a sense of being.
He will never stop beating the drum
of creativity, like Oskar Mazerath
in his novel *'The Tin Drum'*.
"Creativity is a compulsion," Dr Zeig
continues. "We are driven to create.
Compulsions are bigger than the
individuals they inhabit, and they are
not necessarily pathological. We are
compelled to eat, sleep, and create."

Stephen William Hawking was born on January 8, 1942 [300 years after the death of Galileo] in Oxford, England. Since 1979 he has held the post of Lucasian Professor of Mathematics in Cambridge.

Stephen Hawking has worked on the basic laws which govern the universe. With Roger Penrose, he showed that Einstein's General Theory of Relativity implied space and time would have a beginning in the Big Bang and an end in black holes. These results indicated it was necessary to unify General Relativity with Quantum Theory, the other great scientific development of the first half of the 20th Century. One consequence of such a unification that he discovered was that black holes should not be completely black, but should emit radiation and eventually evaporate and disappear. Another conjecture is that the universe has no edge or boundary in imaginary time. This would imply that the way the universe began was completely determined by the laws of science.

Professor Hawking has twelve honorary degrees, was awarded the CBE in 1982, and was made a Companion of Honour in 1989. He is the recipient of many awards, medals and prizes and is a Fellow of The Royal Society and a Member of the US National Academy of Sciences.

Stephen Hawking continues to combine family life [he has three children and one grandchild], and his research into theoretical physics together with an extensive program of travel and public lectures.

VASKE First Question is, Professor Hawking, why are you creative, and the second question is, what is more important, creativity or science?

HAWKING I don't think it's for me to say, whether I'm creative or not. That has to be decided by other people.

And the second question doesn't make sense. You have to be creative to do science. Otherwise you're just repeating tired old formulas. You aren't doing anything new.

"You have to be c
Otherwise you're just r
You aren't doi

ive to do science.
ating tired old formulas.
anything new."

DECONSTRUCTING
PROF STEVEN HAWKING

Prof Hawking once said: "It's better to travel hopefully, than to arrive." Bearing that in mind, let's invite Dr Zeig to deconstruct.
"Creativity", says Dr Zeig, "would seem an anathema to physicists who pride themselves on their empiricism. Their job is to deduce,
not to embroider. Hawking uses logic to investigate the mystery of creation. He does not use creativity to investigate the mystery of
logic. Hawking is an empirical powerhouse. He takes the rational to its edge. Similar to anthropologists, who attempt to understand
through unsullied observation, he purposely withholds creativity. Hawking deconstructs the universe. It is not his job to be creative,
nor does he mean to be creative. He wants to understand creation. Hawking's reply is both humble and rational."

Hegarty began his career in advertising as a junior Art Director in 1965 at Benton and Bowles in London. And almost finished it 18 months later, when they fired him. Luckily [for advertising] he then joined a small up and coming Soho agency, John Collings & Partners, two miles away to Camden Town.

In 1967 he joined the Cramer Saatchi consultancy, which became Saatchi & Saatchi in 1970, becoming a founding shareholder. One year later he was appointed Deputy Creative Director.

John left Saatchi & Saatchi in 1973 to co-found TBWA as Creative Director. The agency was the first to be voted Campaign magazine's Agency of the Year in 1980.

Two years later he left to found Bartle Bogle Hegarty, one of the most successful agencies in London, winning Campaign magazine's Agency of the Year Award in 1986 and again in 1993. Bartle Bogle Hegarty also became the Cannes Advertising Festival's very first Agency of the Year in 1993 by winning more awards than any other agency. It also won the title again in 1994.

John's credits include 'Vorsprung durch Technik' for Audi, and Levi's 'Bath' and 'Launderette'. His honors include two D&AD Gold and six Silver Awards for press and television, and British Television Gold and Silver Awards.

More recently, he received the D&AD President's Award for his outstanding achievement in the advertising industry.

VASKE Why are you creative?

HEGARTY Because it's the only thing I know how to do. It's the only way I know how to think. It's... I enjoy it. And I think with my heart, and that's the best way to be. I think it's just good fun.

SHE'D NEVER MET AN...

HE KNEW THINGS THE OTHERS DIDN'T! LIKE HOW TO SET FRANKLIN GOTHIC EXTRA BOLD WITHOUT IT LOOKING TOO CHUNKY.

With apologies to RO...

LIKE BRAD BEFORE...

MARVEL COMICS.

Hegarty's answer to the question is a perfect example of what advertising does. By using a Lichtenstein 'spot and dot' painting he takes an image from popular culture and changes it. "Well, he had to go and find the picture," says New York psychologist Nicole Henkel. "Therefore one might say that he is not only self-sufficient, resourceful and artful, but also emotionally disciplined. However, he does not lack a sense of humour as demonstrated by the way he responded to its content." Dr Zeig agrees: "John Hegarty is ironic and brazen."

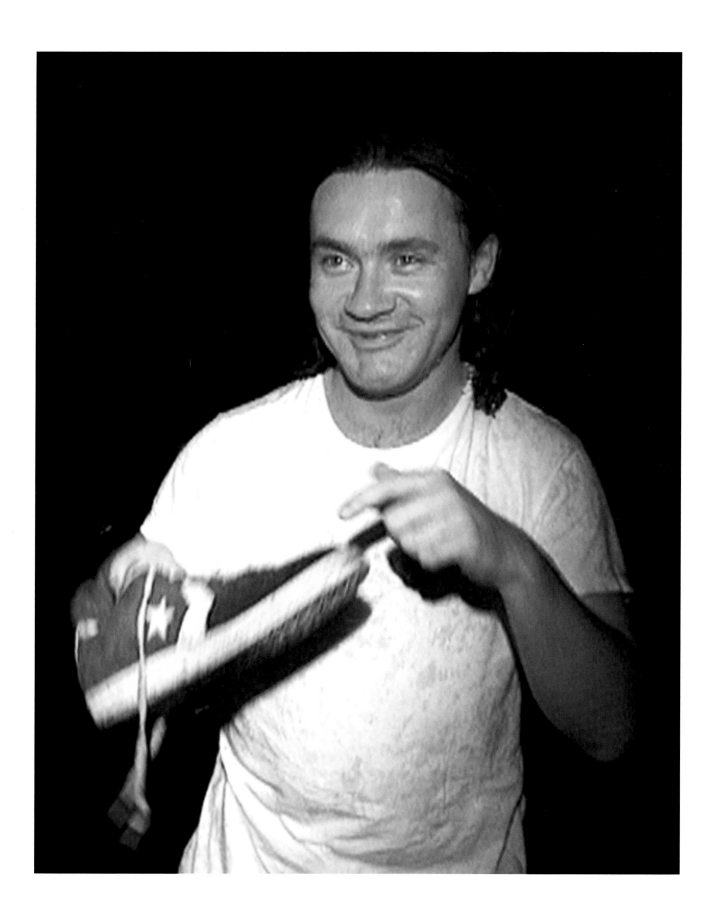

DAMIEN HIRST artist & director

Born in Leeds, England, in 1965, Hirst attended Goldsmiths College in London. He graduated in the 1980s and ignited the young British art scene. In a very short time he has become an internationally recognized artist collected by galleries and private individuals alike.

His hugely distinctive work includes a 12 foot tiger shark in formaldehyde, a cow and her calf sawn in two, house paint flung onto spinning canvases, spot paintings, and a living installation of maggots, becoming flies, and then being electrocuted to death[symbolizing the cycle of birth and death]. The titles of his work are equally creative. He titled his shark in formaldehyde *'The Physical Impossibility of Death in the Mind of Someone Living'*.

In 1994 Hirst received the DAAD fellowship in Berlin, and is a Turner Prize winner.

In 1996 he wrote and directed a short film, *'Hanging Around'*.

In 1997 he had exhibitions at Bruno Bischofberger, Zürich and White Cube, London. In the same year, *"want to spend the rest of my life everywhere, with everyone, one to one, always, forever, now"*, a retrospective of his work and life was published to much acclaim. In 2000 his work was shown at the Gagosian Gallery, New York.

VASKE Damien, why are you creative?

HIRST Ehm, I don't know.

VASKE Let me show you how other people answered the 'Why Are You Creative?' question. Here's Tony Kaye's response.

HIRST When did he do it?

VASKE Over a year ago.

HIRST But why is the blood not brown?

VASKE It's a photocopy... Here's Jay Chiat.

HIRST Jay Chiat, I know Jay. I did a show in his house... I know Saatchi... I know Jay but I never did advertising for him. Charles Saatchi just asked me to do a sculpture for Silk Cut. I do you a drawing.

VASKE Congratulations.

HIRST Art.

Why are you creat
I don't know, I always r
if you give me two obje
to see how they looked

Damien Hirst?
things, it's like collage
would move them around

Dr Zeig comments that:
"Crossfertilization is creative.
The seeds of creativity lie
within us, if we open ourselves
to the process."

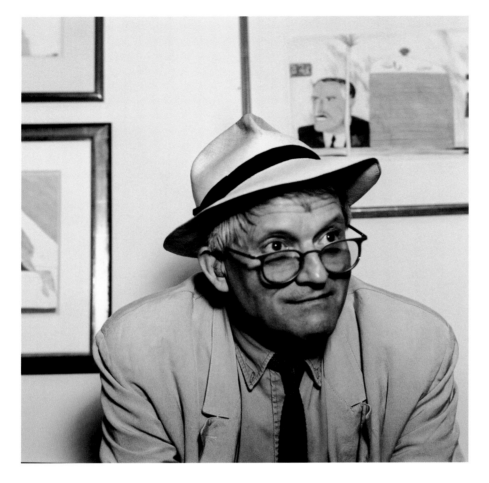

VASKE Why are you creative?

HOCKNEY I suppose I am driven to it. I can't help it. Otherwise I couldn't bear life that much, actually.

Creation is more god-like. Creation and destruction are not an ordinary duality, you have to create something before you destroy it. Creation comes first, or curiosity does in a way, I think that's the source, curiosity.

VASKE What are your creative influences? What about your parents?

HOCKNEY Yes, I mean, my mother had five children, I have not got any. So I guess she was more creative than I am.

David Hockney was born in Bradford, England, in 1937. At the age of seven he decided to be an artist. He studied at the Royal College of Art with Ron B. Kitaj, Allan Jones, Peter Phillips, Derek Boshier and Patrick Caulfield.

In January 1964 Hockney arrived in Los Angeles where he rented a small studio in Santa Monica. *'Man taking a Shower in Beverly Hills'* was his first work with acrylic paint. Pursuing his interest in the instantaneous, Hockney painted *'A Bigger Splash'* in 1967 and explored the paradox between a flat surface and illusionistic perspective.

In 1973 he settled in the Latin Quarter of Paris in a flat which had belonged to Balthus. His focused interest transferred from painting to drawing and engraving.

In 1981 he participated in documenta VI, in Kassel, Germany. In the same year *'A New Spirit of Painting'* was shown by the Royal Academy of Arts in London. The exhibition included four new works by Hockney.

In 1988 the Los Angeles County Museum of Art, the Metropolitan Museum of Art in New York and the Tate Gallery in London showed major retrospectives of his work.

In 1998 Hockney assembled 60 canvases to paint *'A Bigger Grand Canyon'*. One year later the thematic retrospective *'David Hockney Espace/paysage'* at the Centre Pompidou traced his treatment of landscape and space in painting. During the summer of 1998 he published a controversial article in *'RA'* Magazine on his new insight into Old Master technique.

The London Tate Museum opened in 2000 with an entire room dedicated to David Hockney as part of the collection *'RePresenting Britain 1500-2000'*.

In 2001 Bundeskunsthalle in Bonn showed *'David Hockney. Exciting Times Ahead'*.

I need to be.
I love life.

(signature)

**DECONSTRUCTING
DAVID HOCKNEY**

Dr Zeig comments:
"'I need to be. I love life.'
The upward sweep of the
child-like printed letters
portrays an upbeat person,
similar to the sentiment
of the message. Living is
creating. Death is the
antithesis of creation. We
are compelled to create,
just as we are compelled
to breathe, just as we are
compelled to learn."

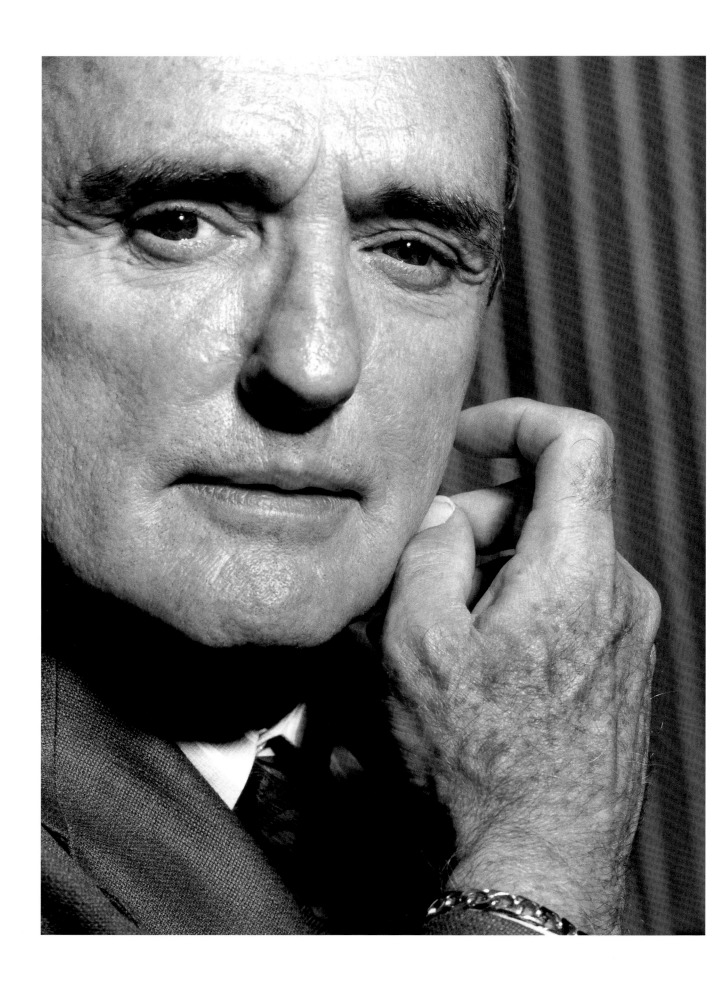

PHOTO Lars Hinsenhofen

DENNIS HOPPER artist, director & photographer

Hopper was born in Dodge City, Kansas, moving to San Diego after World War II.

He appeared in stage productions and early television before landing the role of 'Goon' opposite James Dean and Natalie Wood the classic 'Rebel Without a Cause'.

He played opposite Dean again in 'Giant', and appeared in 'Gunfight At The OK Corral' and 'From Hell to Texas'.

Hopper then went to New York to study with Lee Strasberg for five years.

He returned to Hollywood and worked on independent features 'Night Tide' and 'Key Witness', then starred in several low budget films including 'The Trip', from a Jack Nicholson script.

'Easy Rider' followed in 1969. Made for just $340,000, the film grossed over $50 million and Hopper won Best New Director at the Cannes Film Festival.

In the 1970s Hopper acted in numerous films, most notably Wim Wenders' 'The American Friend' and Coppola's 'Apocalypse Now' and 'Rumble Fish'.

In 1985 Hopper reemerged as a leading actor in 'Blue Velvet', 'River's Edge' and 'Hoosiers' by David Anspaugh, for which he received an Academy Award nomination as Best Supporting Actor.

In 1988 Hopper directed the film 'Colors'. In 1990, he directed a second film, 'The Hot Spot'.

Hopper acted in the Showtime feature 'Paris Trout', for which he received both Emmy and ACE nominations for Best Actor in 1991.

In 1993 he starred in the critically acclaimed 'True Romance', directed by Tony Scott and written by Quentin Tarantino.

In recent years, Hopper has starred in 'Waterworld', 'Witch Hunt', 'Speed', 'Search and Destroy', and 'Black Out' directed by Abel Ferrara. He also directed 'Chasers'.

In addition to acting and directing, Hopper is also a distinguished photographer and painter. He has exhibited his work at the Kiyomizu Temple in Kyoto, Parco Gallery in Tokyo, the Front Colom in Barcelona and Galerie Hans Meier in Düsseldorf.

Hopper's work has been featured in many noted recent museum exhibitions, such as 'Beat Culture and the New America: 1955 - 1965' in 1996 at the Whitney Museum of American Art.

In the year 2001, some of the most important museums in the world, such as the Stedelijk Museum in Amsterdam and the Museum of Applied Arts in Vienna presented Dennis Hopper retrospectives.

VASKE What motivates you? Why are you creative?

HOPPER I think it comes from a very unhappy childhood. Not getting enough approval from the house, from the home. Having to report other places. Having the drive to want to be something, want to be somebody but really not having the education because of schooling to be able to anything but perhaps play sports, fight a ball, race a car, or be an actor. Well, acting was the one that was most … well, I can't say it was the easiest, but it seemed to be the most available to me.

VASKE And you accomplished it 120% and left us with some of the great motion pictures in history.

HOPPER I suppose a lot of it is luck but a lot it is drive to and it's trying to be the best that you can be under whatever circumstances you're working under. And I think it's heart that makes for athletes and makes for actors and makes for anybody that wants something. It's just to keep going, keep hitting it and keep doing it. It should work out if you have a dream.

I was desperate and lonely. There seem tobe no way out

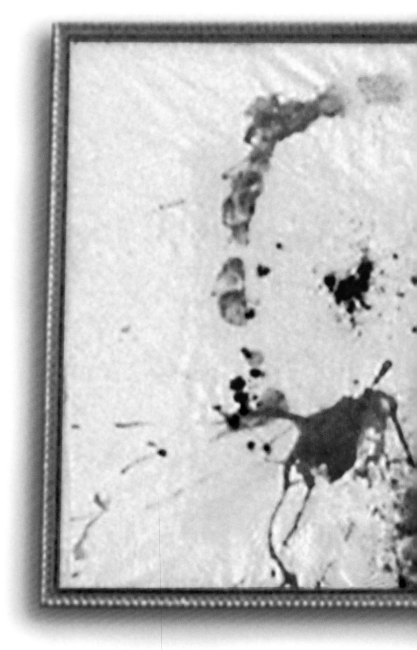

DECONSTRUCTING DENNIS HOPPER

Dennis Hopper is one of the great cross-over artists – straddling the various creative disciplines, as actor, director, photographer, painter, producer, writer. No wonder he provides one of the most original contributions. He answers the question by taking sips of blue, yellow and red ink, and spitting them on to a canvas. He added the words "I was desperate and lonely. There seemed to be no way out."

Henkel comments: "Here we have somebody who expresses himself in two dimensions, actually three dimensions. It's interesting because it shows how both ways, the verbal and the performance one, are important and familiar to him. He is equally comfortable and able to combine the verbal domain with the three dimensional one, which shows his high level of abstract thinking and intelligence. His verbal statement is rooted in the past. It reflects the past. At one point, it was the only thing he could turn to in order to go on with his life. He displays insight by having chosen this productive way out of his desperation and loneliness at the time, and, moreover, strength by having been able to rely on himself."

"It is only in the state of complete abandonment and loneliness that we experience the helpful powers of our own natures." – CARL JUNG

QUINCY JONES musician

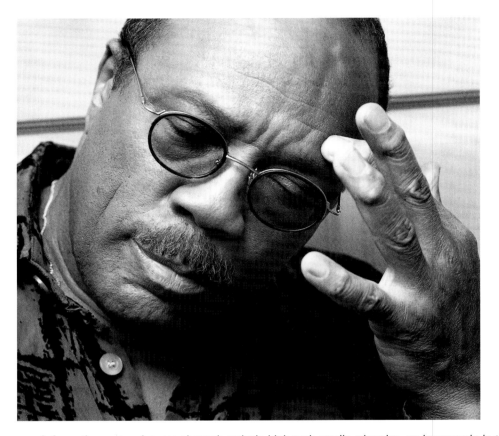

BECAUS

As producer and conductor of the historic *'We Are The World'* recording (the best-selling single of all time) and Michael Jackson's multi-platinum solo albums, Quincy Jones is as one of the most successful and admired creative artist/executives in the entertainment world.

Quincy's musical ventures reach from the post-swing era through today's high-tech studio wizardry, an impresario in the broadest and most creative sense of the word. As the first black composer to be embraced by the Hollywood establishment in the '60s, he helped refresh movie music with badly needed infusions of jazz and soul.

Quincy Jones was born in Chicago on March 14, 1933, and grew up in Seattle. While in junior high school, he began studying trumpet and sang in a gospel quartet. In 1951, he moved to New York and the musical big leagues, where his reputation as an arranger grew. By the mid-'50s, he was arranging and recording for such diverse artists as Sarah Vaughan, Ray Charles, Count Basie, Duke Ellington, Big Maybelle, Dinah Washington, Cannonball Adderly and LeVern Baker.

When he became vice-president at Mercury Records in 1961, Quincy became the first high-level black executive of an established major record company.

Quincy Jones was the executive producer of the most-watched awards show in the world, the 68th Annual Academy Awards in 1996. The show was recognized as one of the most memorable Academy Award shows in recent years. Recently he celebrated his 50th year performing and being involved in music.

VASKE Why are you creative, what's your inspiration? Why are you doing what you're doing?

JONES Something inside at the days of twelve and thirteen told me that I should stop doing what I'm doing which was not very good and get in the music. We were idle minds with nothing to do in Chicago and in Washington and we got into a lot of trouble. And God sent me music and I'm very grateful. I feel very blessed.

SOD GAVE ME MUSIC

[signature]

DECONSTRUCTING

QUINCY JONES

Dr Henkel deconstructs: "Mr. Jones attributes his being creative to God. He is specific in that
he states that God gave him music, and as a result became a musician. His life was predetermined
for him. His answer does certainly not demonstrate arrogance. It rather reflects modesty.
This is a discreet and private man. Mr. Jones further appears to be an emotionally stable, mature
and adaptive individual. Someone one can rely on. The fact that he talks in a humble fashion about
God, leads to the assumption that Mr. Jones is not only a sensitive but also a spiritual man."

PHOTO Donata Wenders

Milla Jovovich is an incredibly versatile artist, not only a gifted, experienced actress but also a talented singer and songwriter.

The Ukranian born Jovovich spent her early childhood in both London and the Ukraine. She moved to Sacramento, California at the age of five when her parents emigrated. Her acting career began at a remarkably early age, starring in several films such as *'The Return to the Blue Lagoon'* and *'Kuffs'*.

Having captivated audiences with her mesmerising performance in Luc Besson's futuristic thriller *'The 5th Element'*, she collaborated with Besson again to play Joan in *'Joan of Arc'*. She also gave an impressive performance in Spike Lee's basketball drama, *'He Got Game'*, opposite Denzil Washington and opposite Jeremy Davies in Wim Wenders' *'Million Dollar Hotel'*.

In addition to acting, Jovovich has also pursued her interests in music, releasing the album *'The Divine Comedy'* in 1994. An introspective, folk-inspired album, it won widespread critical acclaim and took Jovovich on a one-year, nationwide musical tour with her band.

In 2001 Milla Jovovich starred in *'The Claim'*. Michael Winterbottom's adaptation of a Thomas Hardy's novel premiered at the Berlin Film Festival.

VASKE So Milla, why are you creative?

JOVOVICH Well from a dinosaurs' perspective, you know it's been sort of difficult. Because, you know, dinosaurs aren't very accepted into all these different fields and people tend to go for the more normal given view and concept of what an artist is and what they should be. But we dinosaurs, we're big creatures and we like to do lots of things. I can paint with my mouth, and I can talk with my tail and I got to big hands to clap and I've got a big loud voice to say: NO.

Because I

HUN

(handwritten signature)

"Her drawing," says Nicole Henkel
"is approached in a child-like way,
trying to look intimidating. Is this
hunger a hunger for life? This
hungry face seems to be willing
to eat, swallow everything without
discrimination. It looks like a being
that is rolling around the 'jungle' –
our world – feeding off everything
that comes its way. The experiences
this person is willing to make are
endless.
There is a boldness and a sense
of adventure in her statement."

95

Tony Kaye is internationally known for his professional achievements as a commercial film-maker. He has won every major award in the field of advertising as a director and cinematographer, and is one of the most successful directors in the history of advertising.

Following his debut as a feature film director, he is preparing to shoot Tennessee Williams' *'One Arm'* with Marlon Brando.

With 'Don't be Scared', a 1996 exhibition, Kaye created an installation of four naked, healthy-looking women and men to challenge the preconceptions about people with AIDS. It changed the preconceptions about the way artists approach the subject of AIDS, as well as myths about contamination and infection. The exhibition was juxtaposed with newspaper articles and photographs related to AIDS in a manner designed to confront the taboo of AIDS head-on, and in doing so, to create attention that would provide a forum for discussion. 'Don't be Scared' caused a furor in the British press.

Dozens of new articles have been published and aired about Tony Kaye's other conceptual projects. He considers this as part of his process and refers to it as Hype Art.

Kaye has won numerous prizes, including awards the Chicago International Film Festival, Clio Awards Hall of Fame, Golden Lions in Cannes, and D&AD Golds.

His exhibitions have been seen at the Saatchi and Tate Galleries in London.

VASKE Why are you creative?

KAYE Well, I am not really terribly concerned or bothered or interested in wasting any time in trying to figure out why I want to create things. I'm more interested in acquiring the knowledge and skills to be a better creator than what I am.

I wake up and I'm driven by these things that make me want to create things. And fortunately these little angels that are driving me, are always telling me that I need to get better. So that's what I spend my time doing when I'm not doing it, I'm trying to get better doing it. So when I do, it gets as good as it can be.

TONY KAYE, why are you creative?

DECONSTRUCTING TONY KAYE

When I confronted Tony Kaye with
the question, he took a needle and
stuck it into his finger. There was
not enough blood coming out.
Then he took a knife, cut his face
and sprinkled the blood all over the
layout. "Tony is dead now. There
is now a new Tony, hold on to your
seatbelts". Then he said to me:
"You'd better print it bloody quick."
A great, unique answer that com-
municates that there is creativity
in Tony's blood; it's in his DNA.
His award winning films are perfect
proof of this. "To be creative is to
focus one's blood, sweat and tears
on birthing the creative process.
Sometimes, the by-product of
creativity is suffering," says Dr Zeig.
"We are linked by blood, and
blood is memory without language."
– JOYCE CAROL OATES

BEN KINGSLEY actor

Ben Kingsley was born Krishna Ethanji in Scarborough, England, in 1943 to a son of an Indian doctor and a British actress. He changed his name to Ben Kingsley on the advice of his father who told him that if he wanted to be an actor then he had better have an English name. He followed in his mother's footsteps, treading the boards on stage at the age of 19, inspired by a performance of Richard III.

In 1967 he began working with the Royal Shakespeare Company. After making his first movie in 1972, it took another decade before Kingsley returned to the screen. When he did, it was to international acclaim. He lost twenty pounds to play the Indian philosopher and pacifist Mahatma Gandhi in the film of the same name, and won an Oscar for his performance in 1982.

Kingsley has continued to polish his reputation, and has been constantly seeking challenging roles. Few performers could have made the switch from Indian pacifist in *'Gandhi'* to gangster in *'Bugsy'* to Holocaust survivor Itzhak Stern in *'Schindler's List'* to Shakespearean fool in *'Twelfth Night'* with such commanding authority and success.

In 2001 he played opposite Mira Sorvino in *'The Triumph of Love'*, which premiered at the Venice Film Festival.

VASKE Why are you creative, what are your thoughts today?

KINGSLEY Don't tell a story unless it's really urgent. Because we haven't got time. We haven't got the time to mess around. Don't tell a story – unless it's really beautiful and really urgent.

PHOTO O. Grabka / Action Press

**DECONSTRUCTING
BEN KINGSLEY**

Dr Zeig comments: "A more
intrinsic force, a guiding passion,
must light the way. One's *raison
d'être* must be more than cash."
His categoric imperatives
determine his destiny. He has no
choice; without acting and telling
stories there's no life.

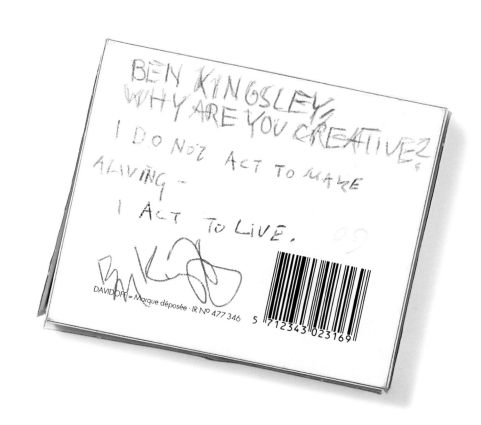

Takeshi Kitano was born in Tokyo in 1947. He entered show business as a stand-up comic in 1972 and became enormously successful as one half of the duo The Two Beats - hence his nickname 'Beat' Takeshi.

He began acting in films in 1981 and won international acclaim for the first time in Nagisa Oshima's *'Merry Christmas, Mr. Lawrence'* in which he played a 'stereotypical' Japanese soldier, Sergeant Hara - obedient, brutal, and sentimental when drunk.

Since then, he has maintained an incredibly prolific and diverse career and has become Japan's foremost media personality. He stars in eight TV programs each week, directs and appears in commercials, and contributes a column to several newspapers. He also writes poetry and serious novels, paints witty cartoon-style pictures, and acts in films for other directors - most recently Robert Longo's *'Johnny Mnemonic'* and Takashi Ishii's *'Gonin'*. He also starred in the adaptation of one of his own novels *'Many Happy Returns'* – a satire of Japanese religious cults, directed by his former assistant, Toshihiro Tenma.

He turned film director in 1989 to make *'Violent Cop'* and now considers film-making his first love. Like his other work, his films challenge Japanese conformity and social taboos. After the presentation of *'Sonatine in Un Certain Regard'* in Cannes in 1993, his films became cult favorites in Europe and North America. In Britain the releases of *'Sonatine'*, *'Violent Cop'* and *'Boiling Point'* are among the all-time best selling foreign language videos.

In 1997 he won the Venice Film Festival with *'Hana-bi'*, and in 2000 he directed *'Brother'* which became a remarkable success.

VASKE Now we come to the question of questions, why are you creative?

KITANO Well, I think it's because I'd die if I couldn't be creative. The ultimate way of making things, the highest form of creativity for me is death. If creativity lies on the opposite side of death, then I'm like a pendulum ... in other words, for me birth is like the ultimate destruction, and death is the ultimate form of creativity. Anyway, I think creating things is like the process of dying.

Translated, Kitano's contribution
reads: "Because I have a big
cannon."
Dr Zeig says: "Kitano subtly
reminds us that the admiration
for our generative and vulnerable
parts unleashes creative energy.
Perhaps he also metaphorically
orients us towards the archetype
of the magic wand, known
through legends as a purveyor of
creativity. Freud determined that
the sublimation of primitive drives
is a creative force. We find within
our primitive passions a font
of potential creative energy."

JEFF KOONS artist

VASKE Why are you creative?

KOONS I guess it is kind of a sense of being able to get out of who I am, or who I defined myself as. Because it gives me kind of a sense of being who I am, and if I'm creative, all of a sudden, I don't have to be that, I can be this, or maybe I can be this, but turned a little bit this way. It's a sense of escapism, but at the same time of escaping, a direction of where it can go is given. If you just try to escape, but you're not really making art, you have nowhere to run, you're just kind of looking around. But if you're true to yourself, you're giving yourself the direction, and it's not a specific direction, but you're increasing this territory that you have a place to run.

VASKE Is sexuality a driving force of your creativity?

KOONS It's a tool. In any type of creative field, there are certain vocabularies that you have to work with, and sexuality of course is one. It's part of the language to use, to be able to manipulate, or at least communicate with somebody.

Jeff Koons studied from 1972 - 1975 at the Maryland Institute of Art in Baltimore and 1975/76 at the Art Institute of Chicago before moving to New York in 1977. He became the star of the New York art scene with aesthetic productions of banal household appliances in luxurious display cases and with the Equilibrium Tanks, tanks with water in which basketballs float.

Soon thereafter, he created figures made of high polish high-grade steel and rococo-like porcelain figures of postmodern icons such as Michael Jackson and the Pink Panther. These technically perfectly produced pieces represent an ingenious mixture of kitsch, sex, and modernity and popularize Marcel Duchamp's idea of the ready made, introduced at the beginning of the 20th century.

Taking his orientation along the lines of mainstream culture to even further extremes, Koons, in the late eighties, focused increasingly on the topic of pornography. In 1991, at the height of his success, he married the Italian porno star Cicciolina and made the relationship the subject of his art. The series of works *'Made in Heaven'* [1991], which shows Koons with his wife as larger-than-life figures having sex, gained him widespread international attention. Since the mid-nineties Koons has been working on the series *'Easyfun'*, *'Easyfun-Ethereal'* and on *'Celebration'*, his largest project so far, which comprises numerous monumental sculptures and paintings.

 PHOTO Volker Hinz

TO HAVE A PLACE AND DIRECTION
TO TAKE MY NEW SELF!

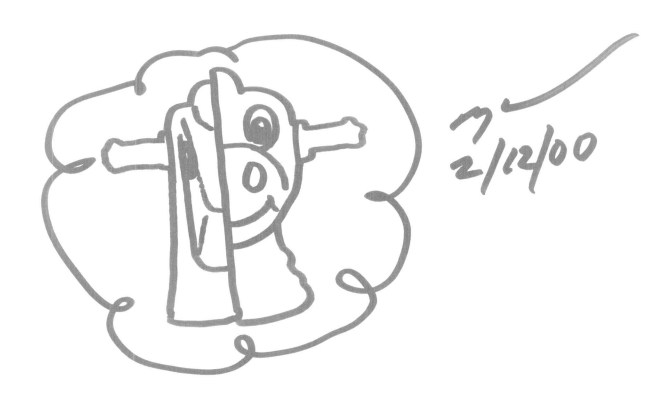

2/12/00

DECONSTRUCTING

JEFF KOONS

Dr Zeig deconstructs: "Art does not recognize itself until it morphs into its final evolution. Koons seems exceptionally aware of his internal process as he creates. As he creates, he invents and discovers himself.
The drawing in the 'thought' bubble is the determined bull that becomes naïve, but content, self-satisfied."

EMIR KUSTURICA director

Kusturica was born in Sarajevo, Yugoslavia in 1954. His films began winning awards even before he had left school. His preco-cious talent took him to the Film Academy in Prague where *'Guernica'*, his final project, gained him first place at the Festival of Student Film in Karlovy Vary.

A year later Kusturica returned home where he began working for Sarajevo TV. His first film *'Here Come The Brides'* caused upheaval and was banned because of explicit treatment of sexual taboos. His next film *'Bar Titanic'* was awarded the prize for Best Direction at the National TV Film Festival in Portoroz. Continuing his gilded career, in 1981 Kusturica won the Golden Lion at the Venice Film Festival for his first feature film, *'Do You Remember Dolly Bell?'*. Four years later he took the Palme d'Or at Cannes.

His fame grew after his award for Best Director at Cannes for his film *'The Time of the Gypsies'* in 1989. Two years later he made his first English language based film *'Arizona Dream'* starring Johnny Depp, Jerry Lewis and Faye Dunaway. Shot on location in Alaska and Arizona, the film was awarded the Golden Bear and the Special Award of the Jury at the Berlin Film Festival in 1993.

In the early 1990s, with his homeland ravaged by war, Kusturica turned his camera on Bosnia. His dark and controversial *'Underground'* earned him a second Palme d'Or in 1995.

In 1999 he released *'Black Cat, White Cat'*, a farce set in a gypsy settlement along the banks of the Danube. In 2001, *'Super 8 Stories by Emir Kusturica'* was highlighted at the Berlin Film Festival.

VASKE Why are you creative?

KUSTURICA Myself, specifically I don't know, because this is a really difficult question. Might be the characteristic, mental characteristics, I inherited from my ancestors - coming from the mountains, being at the same time tender and barbaric, being very violent and very, as I said, tender - and combining all these elements, there was just the question "At which stage in our genes, will there be a time to protect this definitively on film?".

DECONSTRUCTING
EMIR KUSTURICA

For hundreds and hundreds of years Kusturica's ancestors lived in the mountains of Montenegro and Herzegovina.

He is referring to the age-old tradition of resistance to Turkish encroachment lasting some for to five hundred years.

"The Ottoman Empire was everywhere, almost in Vienna, and these mountains were never touched", says Kusturica.

Dr Zeig comments: "We climb mountains to experience the view, to enjoy the journey, to set sights on the next mountain to be climbed. The heights of creative expression are a vantage point, a personal temple offering a unique panorama. Setting our sights on the goal, we invent the pathway."

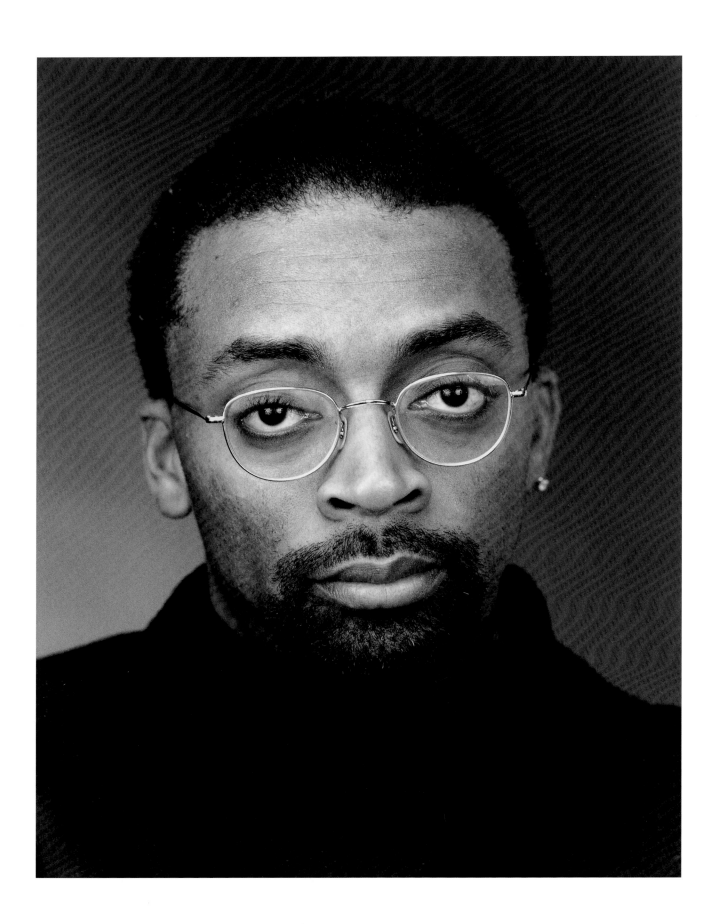

PHOTO David Lee

SPIKE LEE director, producer & actor

VASKE Why are you creative?

LEE Who me? Why do I do what I do?

VASKE Yeah, what drives you?

LEE Well... I just really feel I was... that's why I was put here – to make films.

VASKE Tell stories.

LEE Tell stories.

Born in Atlanta Georgia, Spike Lee attended New York University's Tisch School of the Arts in New York City, where he received a Master of Fine Arts degree in film production. He then founded his production company, '40 Acres and A Mule'.

In 1986, Lee's debut film, the independently produced comedy, *'She's Gotta Have It'*, earned him the Prix of Jeunesse Award at Cannes, and placed him in the vanguard of the Black Wave in American Cinema.

'School Daze', his second feature, was not only highly profitable, but also helped launch the careers of several young black actors. His 1989 film, *'Do the Right Thing'* received an Academy Award nomination for Best Original Screenplay and Best Film and Director awards from the Los Angeles Film Critics Association. *'Jungle Fever'*, *'Mo' Better Blues'*, *'Malcolm X'* and *'Clockers'* also received critical acclaim. In 2001 Spike showed *'Bamboozled'* at the Berlin Film Festival. The film is his first feature on digital video and a wry and sometimes surreal satire on the media circus.

His work on the small screen has been equally successful. He has created music videos for artists as diverse as Miles Davis, Tracy Chapman, Anita Baker, Public Enemy and Michael Jackson. His work in commercials began auspiciously in 1988 with the Nike Air Jordan campaign, collaborating with basketball star Michael Jordan on seven commercials, and resurrecting his popular character, *'Mars Blackmon'* from *'She's Gotta Have It'*.

Lee is also well known for his Levi's Button-Fly 501, AT&T, and ESPN work. His latest commercial ventures include TV spots for Nike, American Express, Taco Bell and Snapple. He has also directed several Art Spot Shorts for MTV.

Spike Lee is also Chairman of Spike/DDB, a subsidiary of DDB Needham Worlwide, responsible for unusual ways of communication.

Spike Lee

WHY IZ YA
DO CREATIVE?

IT'S ALL BECAUSE

OF MY PARENTS.
BLAME THEM.

MY MUDDA JACQUELYN SPELTON
LEE TAUGHT ART AND MY
DADDY BILL LEE IS A
GREAT JAZZ BASSIST/COMPOSER.

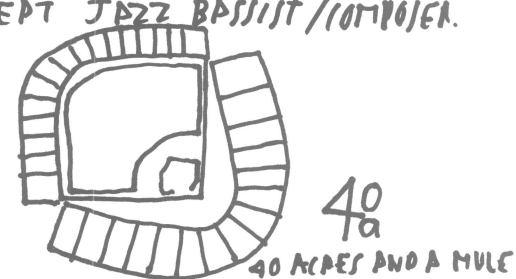

4⁰
a

40 ACRES AND A MULE

②

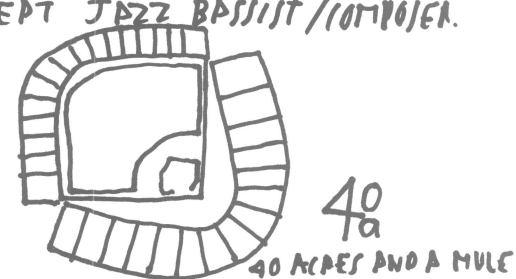

**DECONSTRUCTING
SPIKE LEE**

Dr Zeig says: "Familial and
cultural influences are splints
that shape a soul so that it will
fully realize its creative power.
Innovation is the product of
a creative self-identity, fueled
by a consuming and playful
passion. Ancestry is to destiny
what passion is to creativity.
By igniting the mixture of
his black heritage, his passion
for sports, his parents and
his work in the film industry,
Lee creates."

VASKE Why are you creative?

LYNCH Because there's really nothing more thrilling than getting an idea and then translating it, realizing that idea... bringing something from the abstract to the material.

VASKE What does art mean for you?

LYNCH It's different things for different people and we all have personal tastes. Where they come from we don't know but these tastes can evolve or devolve. What worries me is at the present time, tastes are devolving and very few people um are engaged in what is on the screen or what is in a painting and it's just a one way hollow thrill.

David Lynch is one of the great contemporary directors. He studied at the American Film Institue while making 'Eraserhead', a surreal, often repulsive black-and-white nightmare that became a cult classic. It also piqued Hollywood's interest. Mel Brooks gave him the chance to direct the more mainstream 'The Elephant Man', in 1980. The picture, which was also shot in black-and-white, won eight Oscar nominations and set Lynch on a winning course. After the sci-fi saga 'Dune', the great surrealist directed the masterpiece 'Blue Velvet', an innovatively weird movie featuring Isabella Rossellini and Dennis Hopper.
In 1990 'Wild at Heart', which featured strong performances from Nicolas Cage and Laura Dern, won him the Palme d'Or at Cannes.
With 'Twin Peaks', Lynch's groundbreaking, esoteric TV series; he became a pop-culture phenomenon and made the cover of 'Time'. In 1997 Lynch made another creative splash with his hypnotic feature 'Lost Highway' starring Patricia Arquette and Bill Pullman. Two years later, he shot 'The Straight Story', a small, personal tale about a septuagenarian who drives his '66 John Deere lawnmower from Iowa to Wisconsin to make amends with his long-estranged brother. In 2001 Lynch's creative energy succeeded again. The twisted story of 'Mulholland Drive' won the director the Prix de la mise en scène at the Cannes Festival 2001. Lynch once said: "The ideas dictate everything, you have to be true to that or you're dead." No one is creatively more alive than he is. Compulsively experimental and artistic, Lynch keeps busy by painting, producing records, and drawing a syndicated cartoon strip.

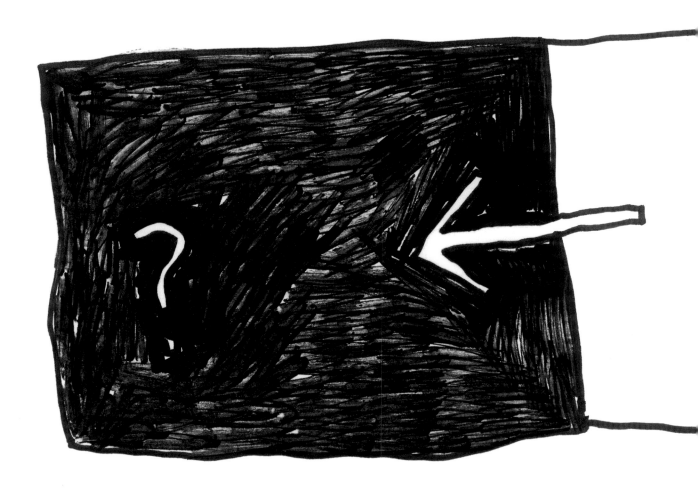

Dr Zeig comments: "The
common road can lead to
uncommon places. Life is
a continuous process of
[self-] discovery.
We can take steps in order
to discover where they take
us. We can only illuminate
the darkness when we begin
the journey.
Opening new territories is
challenging and intriguing.
Curiously, people usually
localize the past to the left
and the future to the right.
To Lynch perhaps the font
of creativity is in our history.
We reconstruct what we have
experienced to make the new
emerge."

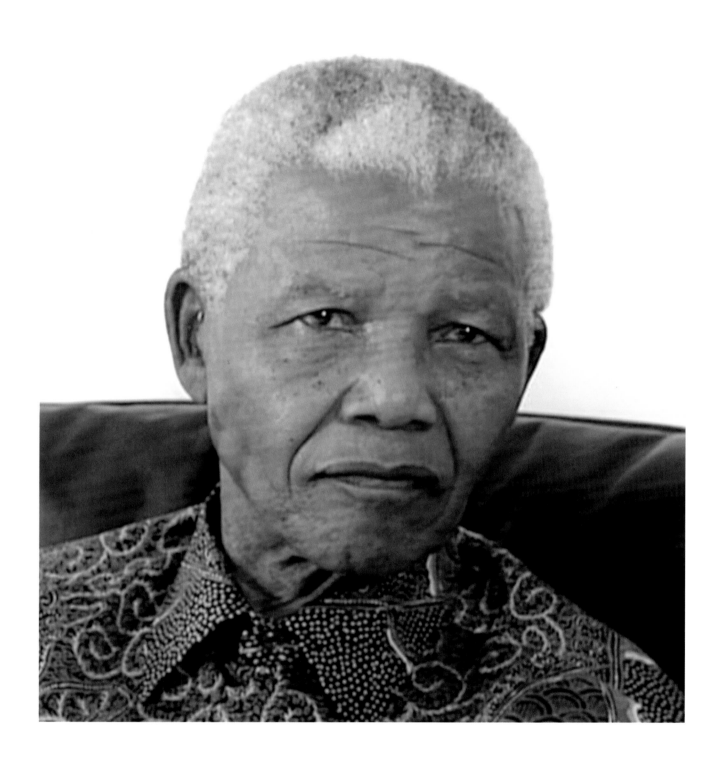

Nelson Rolihlahla Mandela was born in a South African village near Umtata in the Transkei on the July 18, 1918, and was educated to become a lawyer.

In 1944 he helped found the African National Congress Youth League, whose Programme of Action was adopted by the ANC in 1949.

By 1952, Mandela had opened the first black legal firm in the country, and Mandela was both Transvaal president of the ANC and deputy national president.

In 1962, he was arrested for leaving the country illegally and for incitement to strike. He conducted his own defense, was convicted, and was jailed for five years. While serving his sentence, he was charged with sabotage, and sentenced to life imprisonment.

In prison Mandela never compromised his political principles and was always a source of strength for the other prisoners. During the '70s, he refused the offer of a remission of sentence if he recognized Transkei and settled there.

In the '80s, he again rejected PW Botha's offer of freedom if he renounced violence.

Released from prison on February 11, 1990, Mandela plunged wholeheartedly into his life's work, striving to attain the goal he and others had set out almost four decades earlier, a free South Africa for all.

In 1991, at the first national conference of the ANC held inside SouthAfrica after being banned for decades, Nelson Mandela was elected President of the ANC.

Nelson Mandela has never wavered in his devotion to democracy, equality and learning. Despite terrible provocation, he has never answered racism with racism. His life has been an inspiration, in South Africa and throughout the world.

In a life that symbolizes the triumph of the human spirit over man's inhumanity to man, Nelson Mandela accepted the 1993 Nobel Peace Prize on behalf of all South Africans who suffered and sacrificed so much to bring peace to their land.

Nelson Mandela retired from Public life in June 1999. He currently resides in his birth place - Qunu, Transkei.

VASKE Mr. President, do you think we need creative thinking to solve the problems of the Third World?

MANDELA Creative thinking? Oh, I see. Well, creative thinking is absolutely necessary. We don't want sterile views, and clichés which are not related to the specific situation we are addressing. If we want to be relevant, then we have to be creative, and our views should be related to the problem that we are addressing; and it cannot be done in any other way.

There are many
individuals - in
who have dis
Themselves u

MMan
10. 9.

reat we

+ women,—

guished

his regard.

ula

Dr Henkel comments: "An individual,
who directs attention away from
the self to others. In his answer he
talks about other men and women,
not himself. However, he indirectly
acknowledges the fact that he
is creative. His answer is a nice,
humble, sensitive gesture.
Demonstrating a great and noble
being who is rather in the back-
ground than in the frontline, or
limelight. He is somebody who
doesn't take the credit for himself -
he is willing to share it. Given the
fact that he focuses on others in
his answer also indicates that he
is group oriented in nature, and
thus probably attentive and sensitive
to others. The sense of being group-
oriented further leads to the
assumption that Mr. Mandela is
conscientious, dominated by a sense
of duty, concerned about moral
standards and rules, and last but
not least responsible."

VASKE Why are you creative?

MOBY I find it a really difficult question to answer. Essentially, I am thirty-five years old, and I have been making music since I was eight years old, and before that I used to make pictures and write stories. My mother played piano and she was a painter. Everyone in my family has been involved in some sort of creative discipline. So initially my answer would be, I am creative because that's the only way I know how to live. It never really dawned on me to not be creative. Which doesn't necessarily mean that I am good in what I am doing, it just means that active creating or inventing of new things, drawing pictures, writing stories, making music just seems to me like the most natural thing to do.

VASKE Does your creativity thrive more on discipline or on chaos?

MOBY Creativity that's pure chaos can be confusing. But somehow if you combine the beautiful aspects of chaos with the formal aspects of discipline you can end up with interesting creative output.

In 1999 Moby released the album 'Play'. From the spiritual catharsis of those blues sampling tracks like *'Why Does My Heart Feel So Bad?'*, *'Honey'* and *'Natural Blues'* to the mischievously rocky cuts like *'Southside'* and *'Bodyrock'* and on to the introspective middle of the night melancholy of 'Porcelain' and *'Downslow'*, 'Play' offered a multicolored vision of an artist at his creative peak.

More than a year after its release 'Play' has achieved top of the chart status and been awarded Triple Platinum, Platinum and Gold discs in numerous countries including the U.S., Canada, France, New Zealand, Switzerland, Australia, Germany, Ireland, Greece, Italy, Holland, Norway, Belgium, Portugal and Iceland. 'Play' has gone Five Times Platinum in the UK, sitting pretty at the top of the album charts with a brace of hit singles under its belt. A classic case of the public deciding what the public wants.

From performing in small clubs in his earlier years, Moby is now one of the most sought after concert artists. Few people deserve public acclaim quite so much as Moby. His music is always challenging. And his live performances have always been awesome.

VASKE Can creativity solve the problems of the world?

MOBY I think that creativity can create a lot of problems, I think that creativity can solve a lot of problems. I don't know if it's necessarily a good thing to solve the problems of the world. I don't see the world in that way. I don't see the world as a big mess of problems that need to be solved, I see the world as a really interesting miasma of things going on. And something that looks like a problem to us right now might end up looking like a wonderful thing from a future perspective. And something that looks like a great solution now might end up being seen as disastrous from a future perspective.

DECONSTRUCTING

MOBY

Dr Zeig deconstructs: "A Martian on a landscape of breast-shaped mounds looking quizzically toward Earth. Is that how Moby sees himself? An outsider looking in, filled with comic [or is that 'cosmic'] perceptions?

To create one must be "outside-the-box." One must see things in ways that previously have not been perceived. One can nurture irony, a decided source of creative humor.

Creativity is often ambiguous; the viewer must project into the message. Creativity is having a different perspective on things. The signature is playful. Creativity is the essence of play."

HELMUT NEWTON photographer

Born in Berlin in 1920, Helmut Newton was educated at the Werner von Treitschke Realgymnasium until the Nuremberg laws separated Jewish pupils from 'Aryans' in the classrooms.

His father, who was dismayed by his son's wish to become a photographer, then put him in the American School of Berlin. He was expelled from this school for being a hopelessly lazy pupil whose main interests were swimming, girls and photography.

He then apprenticed in 1936 with the Berlin photographer Yva [Else Simon], who was later to be killed by the Nazis in Auschwitz.

After a two year apprenticeship with Yva, he left Berlin on December 5, 1938 for Singapore, where he obtained a position with the Singapore Straits Times as a news photographer. In 1940 he arrived in Australia. After being discharged from the army, he opened a small photographer's studio in Melbourne. In 1948, he married the actress June Brunell [Browne] who, in 1970, took up photography under the name of Alice Springs and was to become a major influence on his work. Newton became a regular contributor to French 'Vogue' in May 1961 and continued to do his most important fashion work there for the next 25 years. During this period he also worked intensively for American, Italian and German 'Vogue' as well as for 'Linea Italiana', 'Queen', 'Nova', 'Jardin des Modes', 'Marie-Claire' and 'Elle'.

The decades from the sixties to the eighties were years of extreme creativity and productivity. It was during these years that the unique originality of Helmut Newton's vision took shape. Recently, his work was published in a book as objet d'art with dimensions of 24"x36" and with its own display table designed by Phillipe Starck.

VASKE Why are you creative?

NEWTON Why I'm creative? Well, I'm having fun taking photographs. It's my live and it's my livelihood. That means I make my money that way, and there's nothing better than getting paid for what you love doing.

VASKE Webster's dictionary describes creativity as putting something into being that didn't exist previously.

NEWTON Well, I think it does exist. Everyone of my photographs has a basis of reality and it comes from daily newspaper-work. It comes from the Paparazzi. I see that happen around me. When I sit in a cafe on a sidewalk in Paris or Hollywood, I'm a sort of professional voyeur. The real life provides me with the most outrageous things. Nothing can beat real life for being bizarre.

MR. NEWTON,
WHY ARE YOU CREATIVE?
I didn't know I was.

Hel

**DECONSTRUCTING
HELMUT NEWTON**

Dr Henkel comments:
"A busy individual who
seems surprised by the
fact that others see him
as being creative. Too
busy to notice, or too
humble to acknowledge
and realize oneself as
such? Mr. Newton's
unpretentious or unas-
suming response makes
him a pleasant individual.
He appears to be recep-
tive. He respects others
and is sensitive towards
them. After all, he allows
someone else to point out
to him that he is creative."

BEN NOTT director

Ben Nott was born in Australia in 1969. He started his career as an advertising creative at DDB Sydney and in New York. He became the youngest person ever to win a Grand Prix at Cannes and at Eurobest and the only person ever to win both. The winning ads were for 'Kadu' (a fashion label), and for a campaign against racism. He attended film school and began directing his own films while working for DDB in Sydney, and New York. The first film he created and directed was for the Camperdown Children's Hospital in Australia, which won Gold at the New York Festival. Since then he has directed over 30 commercials. His recent work includes ads for the Beavis and Butthead program on MTV, Reebok, Volkswagen, Samsung, Dr Pepper and Guinness.

Nott's other interests include cartooning, photography and surfing, [As an ex-top Australian competitive surfer, he even surfs when visiting England – "even when there's snow on the beach"]. In 2002 Nott will be directing a film on surfing, skiing and skating.

NOTT Why am I creative? I guess, because my father is an artist. I grew up in art galleries, then film school and advertising creative departments, most of them on earth. But the motivation has always been because I get extreme joy from the creative process.

VASKE What's your inspiration?

NOTT My addition to that extreme joy – the mental orgasm of getting a great idea. Plus everything I see, hear, sense. Awake and asleep. And, of course, everything I haven't seen yet.

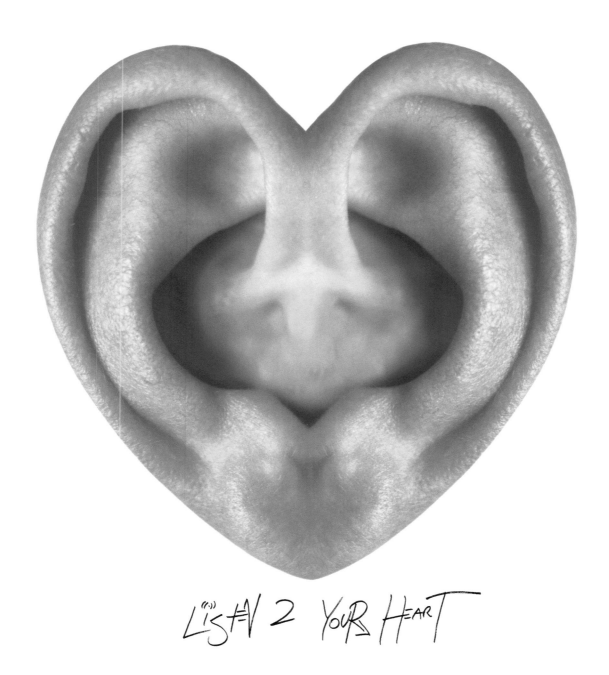

LISTEN 2 YOUR HEART

DECONSTRUCTING

BEN NOTT

Dr Zeig comments: "Psychologists have researched synaesthesia, a talent of sensory 'cross over', whereby a person can, for example, 'see' music. Nott uses this technique to assemble the commonplace and to create novelty: Ears create love." Nott further delights us by enriching simple and mundane words and numbers with hidden meaning. "Creativity goes beyond the concept. In his attention to detail, like a poet carefully choosing words, each of Nott's visual elements is rich with multi-level meaning, creating a compelling image of passion."

"If you are an artist, you try to keep an ear to the ground and an ear to your heart." – BRUCE SPRINGSTEEN

YOKO ONO artist & musician

Yoko Ono was born in Tokyo, in 1933. Because her father worked in an international bank, her family had to relocate many times, from Japan to San Francisco to New York, before returning to Japan.

After World War II, Ono studied at the renowned Gakushuin School and then at its University. When her family returned to America, she studied music at Harvard Summer School, then philosophy and composition at the Sarah Lawrence College.

In 1956 she married the Japanese avant-garde composer Toshi Ichiyanagi and moved with him to a loft in New York. It was this loft at which many of the legendary 'Fluxus' performances took place in the early 1960s. This group included, among others, Marcel Duchamp, George Maciunas, John Cage, Max Ernst and Peggy Guggenheim. Ono's eventful and diverse life in New York helped her develop a unique singing style, fusing a blend of traditional Japanese and Western elements. She met John Lennon in 1966, with whom she lived until Lennon's tragic death in 1981.

In the 1990s Ono created installations and objects which had a political and feminist link. Since 1996, she has been working with her son Sean, and his band IMA. In 2001, she received a honorary degree from the University of Liverpool. The same year Minneapolis' Walker Arts Center mounted a forty year retrospective of her work titled 'Yes, Yoko Ono'.

YOKO ONO,
WAY ARE YOU CREATIVE?

Because I am what I am

Y. O.

**DECONSTRUCTING
YOKO ONO**

Yoko Ono, not surprisingly, emerges as being at peace and in harmony with herself. Dr Zeig interprets her contribution as a reminder that creativity is an essential aspect of our person, that to be a person is to be creative.

PHOTO Volker Hinz

Sean Penn was born the second of three sons to actress Eileen Ryan and director Leo Penn. In 1980, Penn moved to New York, and promptly landed both his debut feature-film role, in *'Taps'* [1981], and an off-Broadway appearance, in a production of *'Heartland'*.

He then delivered break out performances in *'Fast Times at Ridgemont High'* and in John Schlesinger's fact-based drama *'The Falcon and the Snowman'*.

After performances in *'Casualties of War'* and in *'State of Grace'* [1990], he completed work on his debut directorial effort, *'The Indian Runner'* in 1991. His second effort as writer-director-producer yielded 1995's *'The Crossing Guard'*. That same year, Penn pulled off a shattering, Oscar-nominated performance as convicted rapist and murderer, Matthew Poncelet, in Tim Robbins' death-row drama *'Dead Man Walking'*.

In 1997 Penn was the Executive Producer and Star of *'She's So Lovely'*, based on a script by the late John Cassavetes. He took home the Cannes Film Festival's Best Actor Prize for his performance in the latter film. His appearance as Michael Douglas' brother in the David Fincher cyber-thriller *'The Game'* was followed by a star turn in Oliver Stone's *'U-Turn'*. In 1998, he appeared in Terrence Malick's *'The Thin Red Line'*. In 1999 Penn received an Oscar nomination as a sleazy, drunken jazz guitarist in Woody Allen's nostalgic *'Sweet and Lowdown'*.

In 2001 Penn directed *'The Pledge'*, starring Jack Nicholson. The film premiered at the Cannes Festival, and was very well received.

VASKE What are your creative influences?

PENN Um, creative influences... I grew up in a very creative home. My parents were involved in the theatre, and painting and writing, and, so I'm sure that had an impact. Now, I think, as I've gotten to be able to do things creatively, you know, and that it's turned out that it's in movies mostly, I find that the things that are occupying your experience at the time fuel what you do creatively. You know, and the things that the questions that you're looking to find, not answers to, but some kind of, hoping, are worth pursuing creatively, you know, to motivate that.

VASKE Why are you creative, what drives you?

PENN Because, I guess it has the faint sound of an activity that I can be productive in, with whatever it is that I know how to do, and would stay motivated to do. It doesn't feel like a waste of time.

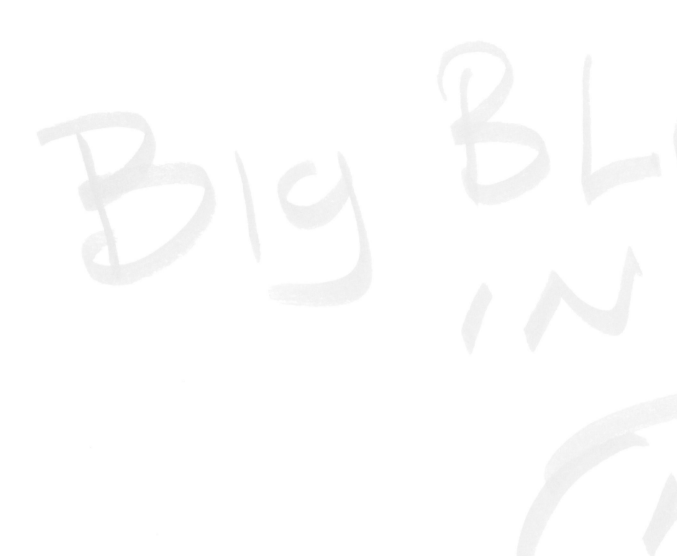

DECONSTRUCTING
SEAN PENN

Dr Zeig deconstructs: "Penn moves with the creative flow of his unconscious process. He does not seem to censor."

Dr Henkel adds: "Obviously not a man of many words, on the good side, he does not appear to be an obsessive talker. Nonetheless, he presents himself as being decisive and an interesting individual."

JOE PYTKA director

Joe Pytka is considered by most to be the pre-eminent director of television commercials. He has more than 6,000 commercials to his name, two feature films, *'Space Jam'* and *'Let it Ride'*, and several music videos.

Many of Pytka's creations have become part of the American cultural vernacular. His classics include the *'Thank You for Your Support'* campaign for Bartles & Jaymes; the *'Bo Knows'* ads for Nike; Michael Jordan and Larry Bird playing *'Nothing but Net'* for McDonald's, and Ray Charles singing *'Uh huh'* for Diet Pepsi. He is also responsible for the hot-rod infant in the Dupont Stainmaster ads and for bringing together former Governors Ann Richards and Mario Cuomo in their Frito-Lay commercial.

Pytka was born and raised in the Pittsburgh suburb of Braddock, Pennsylvania, and has always had a flair for all things visual – studying art at Pittsburgh's Carnegie Museum at the tender age of eight.

He was accepted into the art program at Carnegie Tech [now Carnegie-Mellon-University], but instead, opted to follow his father's advice to "do something practical" and enrolled at the University of Pittsburgh with the idea of studying chemical engineering. That brief sojourn proved to be, in his own words, "disastrous" and chemistry's loss became America's gain, when Pytka took a job at a film lab in Pittsburgh, where he learned the basics of his craft.

His first break came when he got the chance to shoot some documentary footage for WQED, the public broadcasting station in Pittsburgh. He started shooting commercials to supplement his income, and hasn't stopped since. In 2000 Pytka picked up Gold Lions at the Cannes Advertising Festival for Alta Vista and Stamps.com.

VASKE Why are you creative, Joe?

PYTKA The word creative is kind of a strange word. I'm not sure what that word means. I argue back and forth about what creativity is and what I think is, I'm a craftsman. I think I just do my craft. I kind of analyse the problem that's given me and do it as well as I can using whatever skills I can use of my own, and take advantage of other people's skills. Because ninety five or ninety nine per cent of my work is taking advantage of other people's skills. The set designers, the cameramen, the lighting people, the actors, stuff like that.

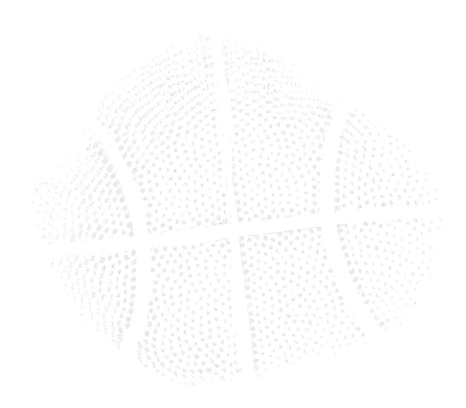

DECONSTRUCTING

JOE PYTKA

"To Joe Pytka creativity is a playful amalgamation of passions," says Dr Zeig. "Combining interests can spark creativity. Taking interests that seem disparate on the surface and joining them, may foster invention."

Nicole Henkel goes deeper: "This person is not about pleasing but about statements. He uses a forceful energy to express himself, which might very well be read as an aggressive tendency. However, this quick response is not impulsive. This man knows what he is doing and has no time for bullshit. He does not expect the world to agree with him, which makes one conclude that he is a rather self-assured, self-reliant, and self-confident individual."

Keith Reinhard heads the largest agency network in the United States and the second largest in the world. But, because Reinhard arrived at his position as DDB's Chairman and Chief Executive Officer by way of the Creative Department, he is most proud of his agency's creative record.

Based on their consistently creative performance, DDB agencies have been named Agency of the Year in 15 countries, including the US, over the past 11 years. Last year, again based on outstanding creativity across cultures and national borders, the DDB network was named by Advertising Age as its first-ever Global Advertising Agency of the Year.

As a working creative man, Keith was best known for his enduring campaigns for McDonald's *'You Deserve a Break Today'*, *'You, You're the One'* and the Big Mac tongue twister, 'Two-all-beef-patties-special sauce-lettuce-cheese-pickles-onions-on a sesame seed bun'. Over the years, Keith has served on most of the major award juries. In 1984 he was a member of the Cannes jury and was elected by that jury as its first-ever American president.

In 1986 Keith was one of the architects of the advertising industry's first and only three-way merger which created Omnicom, the world's largest advertising group. Keith's vision was to create a new DDB capable of bringing to life the insights of DDB founder Bill Bernbach, and apply them broadly to the modern world.

Advertising Age has referred to Keith Reinhard as the advertising industry's 'soft-spoken visionary' and The Wall Street Journal has included Keith in its well-known 'Creative Leaders' campaign. Keith believes that successful advertising combines relevance, originality and impact [his definition of ROI] all at the same time. He is passionate about the transforming power of creative ideas, and he shares Bill Bernbach's belief that, properly practiced, creativity can make one ad do the work of ten.

REINHARD I believe the purpose of research is to fuel the creative process with knowledge and insights and to check creative hunches. It is essential in this role, but dangerously inept when it attempts to predict the future. I do not believe, despite mounting opinion to the contrary, that creative output is a commodity available in comparable quality from any agency. At the same time I do not believe our brand of creativity is yet good enough to disprove that opinion.

INSTRUCTIONS: DO NOT COLOR OUTSIDE THE LINES

KEITH REINHARD, why are you creative?

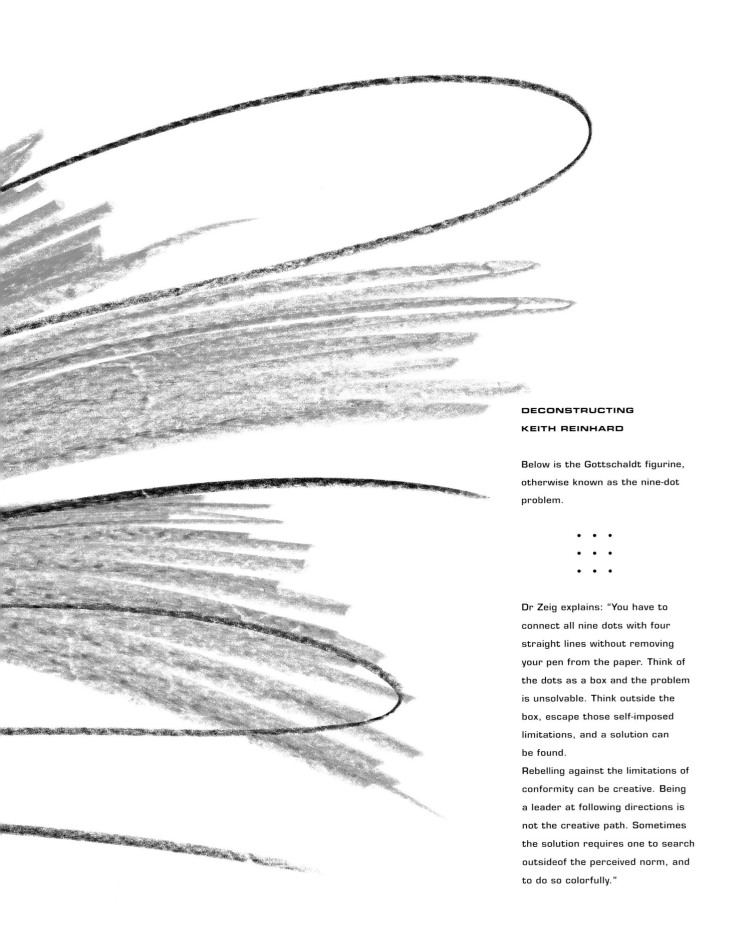

DECONSTRUCTING
KEITH REINHARD

Below is the Gottschaldt figurine, otherwise known as the nine-dot problem.

. . .
. . .
. . .

Dr Zeig explains: "You have to connect all nine dots with four straight lines without removing your pen from the paper. Think of the dots as a box and the problem is unsolvable. Think outside the box, escape those self-imposed limitations, and a solution can be found.
Rebelling against the limitations of conformity can be creative. Being a leader at following directions is not the creative path. Sometimes the solution requires one to search outsideof the perceived norm, and to do so colorfully."

LENI RIEFENSTAHL director & photographer

Leni Riefenstahl, was born into her controversial life in Berlin in 1902. She is best known as Hitler's movie maker, and was hailed by the *New York Times* as "one of the greatest female film makers ever".

She left home at 21 to study dance, and perform in Munich, Berlin and Prague. Inspired by Arnold Franck's film *'Mountain of Destiny'*, she started to get roles as a daredevil actress in *'German Mountain'* films. Despite the fact it was a male-dominated field, Riefenstahl became a director of stunning narratives, like *'The Blue Light'* [1932]. This attracted the attention of Hitler, a great admirer of her art, who asked her to film a documentary of the Nazi Party rally in Nuremberg.

In 1936 she was put in charge of managing a total crew of 60 cinematographers to film the Berlin Olympics. The result is considered a cinematic masterpiece.

Following the war in 1945, Riefenstahl could not resume her career as a director. The movie *'Tiefland'*, which she had begun in 1940, finally premiered in 1954, but it would be the last release of a new film directed by Riefenstahl.

After living in Africa, she published two photographic essay books on her anthropological photographs and home movies of the now extinct Nuba tribes. At the age of 72, she took up scuba diving, and experimented with underwater photography until she was well into her '90s.

While she never actually joined the Nazi party, as the creator of the single most effective propaganda film ever made – *'Triumph of the Will'* – Riefenstahl has spent much of her life trying to live down her association with the Third Reich.

RIEFENSTAHL Well, I think I'm most of all a visual person. Since I was young I was drawn to images, to certain things, and I always had the desire to form and design these things into images, and if possible, to dramatise them, to create something that is whole. I am very lucky to be able to do it for such a long time.

VASKE How did the invention of the photographic camera change creativity?

RIEFENSTAHL The camera - it's because of the camera the art of making movies exists. There was art before, but not the art of film. Michelangelo had many talents, he was a genius, an artist, But there was no film. There were painters, musicians, poets. To me the art of film is the connection of image, sound and movement. A new form of art... Just to have a good idea doesn't make one creative. An idea itself is not creative. Creativity is nothing you are aware of, it's something that's absorbed at a subliminal level. Everything else is not creative.

DECONSTRUCTING

LENI RIEFENSTAHL

Surprisingly, Riefenstahl, one of the most controversial creative figures, exhibits spirituality in her contribution. "Creativity is a gift from god" is the English translation of Leni Riefenstahl's answer. Dr Zeig comments: "As she speaks from her pulpit of age and experience, Leni Riefenstahl's response reminds us that 'Creativity is a gift from God'. It is essential to our human nature.

"Gifts are perishable; they must be used. Our creativity can be presented with grace, rather than hoarded.

As the saying goes: 'What we are is God's gift. What we become is our gift to God'.

"'God is love', the bible reminds us. And we are all love's creation." Some people like Professor Flynn Picardal compare Hitler and Riefenstahl's relationship to a Faustian pact and believe that "Riefenstahl sold her soul to the devil, in order to reach the highest artist achievement possible. So she used the devil to fullfill God's gift."

SALMAN RUSHDIE writer

RUSHDIE I was interested to note that in the answer, that Günter Grass and I, without conferring, gave exactly the same answer, which is that we have no choice; you do it because you have to. I have always felt that there are enough books in the world, so if you are going to add a book to that, it has to be because you have no choice in the matter; because the book insists on being written.

And those are the books I have always tried to write.

Rushdie was born to Muslim parents in Bombay, India.

He emigrated to Britain in 1965, and studied at Cambridge University. He then worked as an actor and advertising copywriter before becoming a full-time writer, producing his first novel *'Grimus'* in 1975.

He became widely known after the publication of his second novel, *'Midnight's Children'* which, in 1981, won the Booker Prize and the James Tait Black Memorial Prize. A fantastic interpretation of Indian history in the twentieth century, *'Midnight's Children'* was followed in 1983 by *'Shame'*, set in Pakistan.

In 1988, Rushdie's *'The Satanic Verses'* earned him the Whitbread Novel Award and a 'fatwa', a sentence of death passed on him by Ayatollah Khomeini of Iran, because of the book's treatment of Islam from a secular point of view.

In 1989 Rushdie was forced to go into hiding.

His later books include a novel for children, *'Haroun and the Sea of Stories'* [1990], a book of essays, *'Imaginary Homelands'* [1991], the novel *'East, West'* [1994] and *'The Moor's Last Sigh'* [1995]. Rushdie's latest novel *'The Ground Beneath Her Feet'* a roller coaster ride through music and pop, was published in 1999. It was put in the shredder by Madonna and highly recommended by Bono.

SALMAN RUSHDIE,
WHY ARE YOU CREATIVE?

Because I seem to
have no choice in
the matter.

DECONSTRUCTING
SALMAN RUSHDIE

Salman Rushdie has had no choice
in his struggle.

For him, it is his destiny: a destiny
which confronted him with a death
sentence, reduced by Khatami only
to be enlarged by others.

Few people have suffered for their
art to such an extent.

His destiny remains unknown. It is
the price he pays for his creativity.

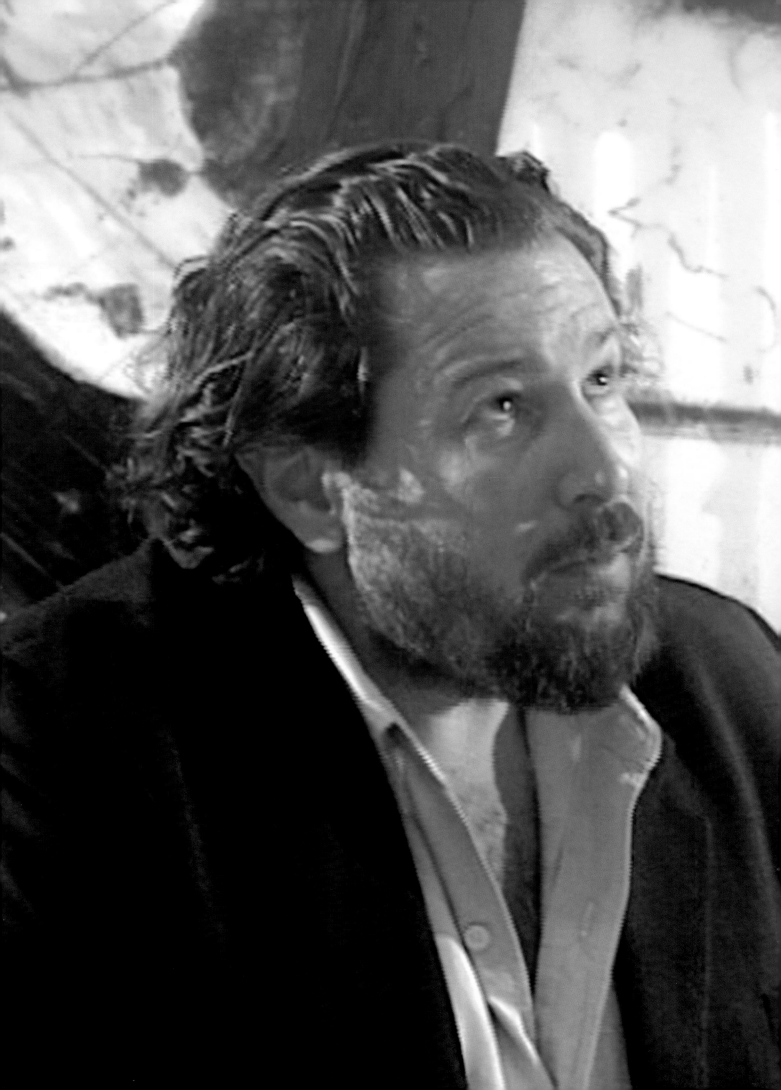

JULIAN SCHNABEL artist & director

Julian Schnabel was born in 1951 in Brooklyn, New York. When he was 14 his parents moved to Brownsville, in the Texas countryside, where he escaped loneliness through painting.

He had his first solo exhibition in 1979, and has enjoyed phenomenal success ever since, with his paintings and sculpture exhibited in galleries and private collections worldwide.

In 1996, after six years of research and writing, Schnabel made his debut as a director with *'Basquiat'*, a film celebrating the life of his friend the artist Jean-Michel Basquiat who died of a heroin overdose at the tender age of 27.

In 2001 his new film *'Before Night Falls'* was nominated for an Independent Spirit Award and brought actor Javier Bardem an Oscar nomination in the category of 'Best Actor'. As a crossover artist Schnabel also entered the music arena, recording the critically acclaimed *'Every Silver Lining has a Cloud'*.

Schnabel lives and works in New York City.

VASKE So, Julian why are you creative ?

SCHNABEL It's funny 'cos I didn't know that I was creating anything. I mean everything seems to be part of the world already, and maybe I just sort of pull it out of something that already exists in a way. I've always made things, that's just the way that I've always behaved from the time I was a child, so I never thought I was being creative, I just thought I was passing my time in the world. So, I guess I had a talent for drawing when I was a child. And my mother was very enthusiastic so I continued because that was the only thing that I could do well. Later on I got more philosophical about it maybe. But I think I had a very Pavlovian beginning.

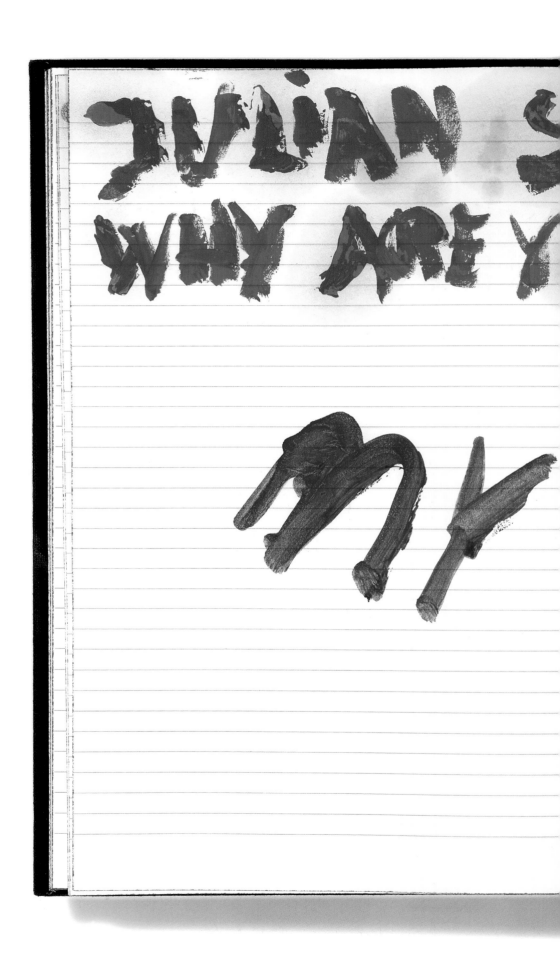

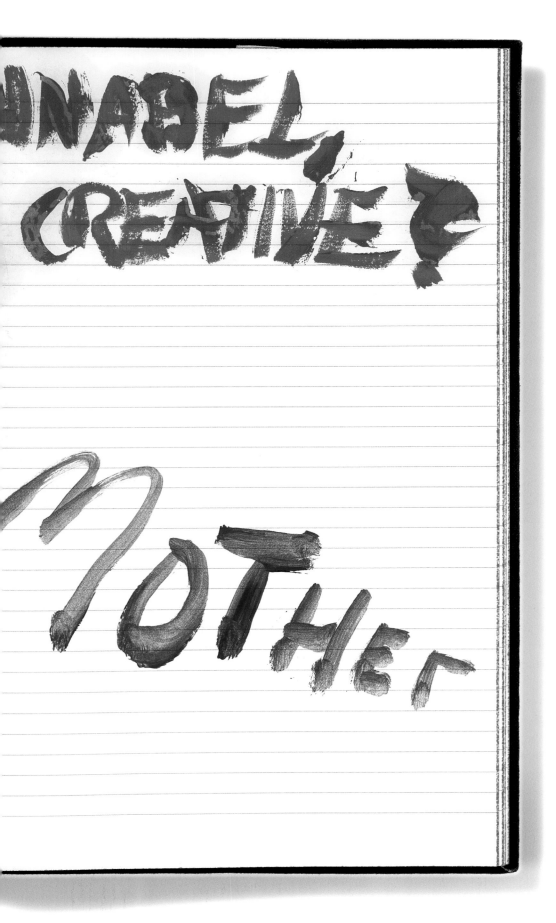

NABEL CREATIVE?

MOTHER

Dr Zeig comments that,
in a renowned therapist's
study and given no
prompting, it took a mere
five minutes in the first
session for the average
patient to pronounce
the sacred word 'mother'.
"Perhaps Schnabel had
a mother who utilized her
creativity to nurture his.
Perhaps she was so strict
he did not have toys and
was forced to stretch
his creativity. No matter.
Each of us has had
a creativity-inspiring
'mother', if not in reality
then there has been a
substitute 'mother muse'
who fostered creativity."
The depth of Schnabel's
relationship with his
parents can be seen in his
feature film *'Basquiat'*,
where he gave his parents
a central role.

Tony Scott was born in 1944, in Stockton-on-Tees, England, the younger brother of Ridley Scott, the director of *'Aliens'*, *'Blade Runner'* and *'Thelma and Louise'*.

His commercials for Levi's, Fiat and Marlboro won all the awards the advertising industry has to offer, and earned him a reputation for being a hugely talented visual storyteller. This led to his elevation to the 'Famous Five', the Hollywood invasion of British commercial directors: Alan Parker, Hugh Hudson, Ridley Scott, Tony Scott, and Adrian Lyne.

While Scott's first feature film, *'The Hunger'* starring Susan Sarandon, Catherine Deneuve and David Bowie, was criticized for a lack of storytelling, his second film – *'Top Gun'* – starring Tom Cruise was a huge success. This was followed by a whole list of blockbusters with the producers Jerry Bruckheimer and Don Simpson: *'Beverley Hills Cop 2'* with Eddie Murphy, *'Days of Thunder'* with Tom Cruise, *'The Last Boy Scout'* with Bruce Willis, *'Crimson Tide'* with Gene Hackman, *'The Fan'* with Robert De Niro, and *'Enemy of the State'* with Gene Hackman.

VASKE Why are you creative?

SCOTT Because it's just a brilliant way to spend your life. I mean it's a brilliant way because no two days are the same. That's what excites me most you know. I always pursue something but I'm creating as well and I can create with $60 million, so it's a bit like being the President of the United States. I used to create on a canvas with a paint brush you know, but now I bring that same process with $60 million. I get actors and cameras and people and things and toys and I've brought my painting process, I've adapted that to the process of movie making.

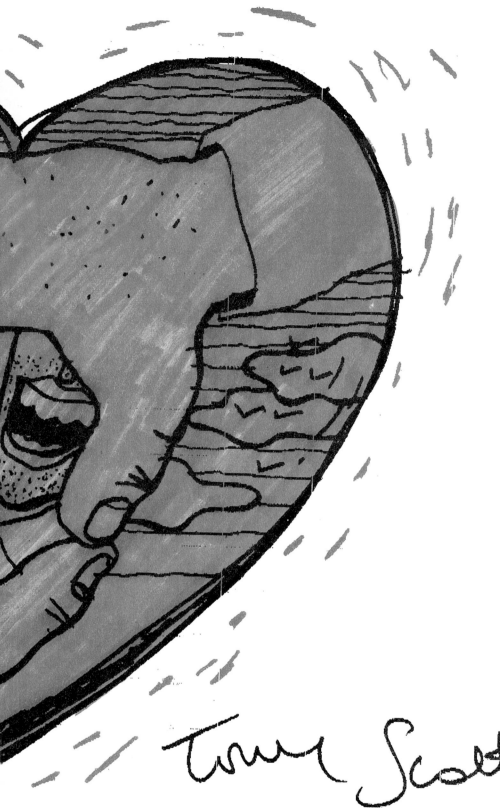

DECONSTRUCTING
TONY SCOTT

Tony Scott draws his hands
forming the viewfinder with which
he frames the world.
The heart symbolizes his love and
passion for directing. He loves
nature, he loves the people, he
loves the sun, he loves the wind,
he loves to be creative.
Dr Zeig comments: "The artistic
ambiguity in Tony Scott's contri-
bution activates our search for
meaning. Ambiguity requires the
recipient of the artwork to project,
and thereby, create meaning from
the artist's creation. Thus the
artist and the viewer co-create the
art. And the derived meaning is as
unique as the individuals involved."

MARCELLO SERPA advertising creative

He is recognized as Brazil's most honored art director. In 1993, he won Latin America's first Grand Prix at the Cannes Festival. During the last seven years he has won an additional forty Lions. He is the most awarded art director in the 25year history of the Club de Criação of São Paulo and the most honoured Brazilian at the Art Directors Club of New York. He holds Latin America's only two gold medals. He is winner of two Grands Prix at the New York Festivals, of Gold and Silver statues at the Clio Awards and of three Grands Prix at the FIAP [Iberoamerican Advertising Festival]. He is the first Brazilian art director to receive Gold at the One Show. In three consecutive years, he was named Best Creative Director in Latin America and Brazil at Latin Spots Magazine's 3El Ojo de Iberoamerica2 Awards; in 2000, he was Chairman at the 3rd Asia-Pacific Advertising Festival and Jury President at the Cannes Festival.

VASKE Why yourself, why are you creative?

SERPA I have no idea!

**DECONSTRUCTING
MARCELLO SERPA**

Happiness and creativity are
mortar and pestle.
Looking at Serpa's contribution
Dr Zeig says: "Our most creative
acts may be generated by our
happiness, and reciprocally,
our creativity generates our
happiness. Creativity need not
be born of misery. Give a child
crayons. Immediately he will
create."

PHOTO Patrick Swirc / Rapho / Focus

Steven Spielberg was born in 1946 in Cincinnati, Ohio, to a Jewish family whose European relatives died during the Holocaust.

He began directing short films at college then progressed to the small screen, directing three television movies for the TV series *'Night Gallery'*. His film career proper began in 1974 with *'The Sugarland Express'*, a chase movie starring Goldie Hawn and William Atherton.

Commercial success came the following year with *'Jaws'*. And his first Oscar nomination came in 1977 for *'Close Encounters of the Third Kind'*.

His first double nomination – for Best Producer and Best Director – came for *'Raiders of the Lost Ark'* in 1981.

Two more Oscar nominations quickly followed, for *'E.T.'* and *'The Color Purple'* – Spielberg's first foray into serious drama.

1993 found Spielberg at the height of his powers. 'Jurassic Park' became the highest grossing movie ever, winning three Oscars for special effects, and *'Schindler's List'*, won him his first Best Director award.

In 1994 he teamed up with Jeffrey Katzenberg and David Geffen to form Dreamworks SKG, a multi-media production company, directing *'Amistad'* for the studio in 1997.

He won his second Best Director Oscar for *'Saving Private Ryan'* in 1999.

In 2001 *'America's Homer'*, as *'Life'* called Steven Spielberg, directed *'A.I. - Artificial Intelligence'* starring Haley Joel Osment and Jude Law. The film was shown at the 49th Venice Film Festival, and was enthusiastically received.

Spielberg involves himself in numerous charity and social activities, particularly in his support for the Shoah Foundation, a visual archive honoring and remembering the suffering of the Jewish people in the Second World War.

I was born that way because of my Mother & Father

DECONSTRUCTING
STEVEN SPIELBERG

Dr Zeig says: "A hallmark of
Spielberg is returning to his
roots, discovering how our
forebears shaped us, how we
can pay homage to their toils.
Spielberg frequently honors
his parents publicly."
Speaking at the 71st Academy
Awards ceremony in 1999,
Steven Spielberg said:
"...and Dad you're the greatest.
Thank you for showing me that
there's honor in looking back and
respecting the past. I love you
very much. This is for you.
Thank you."

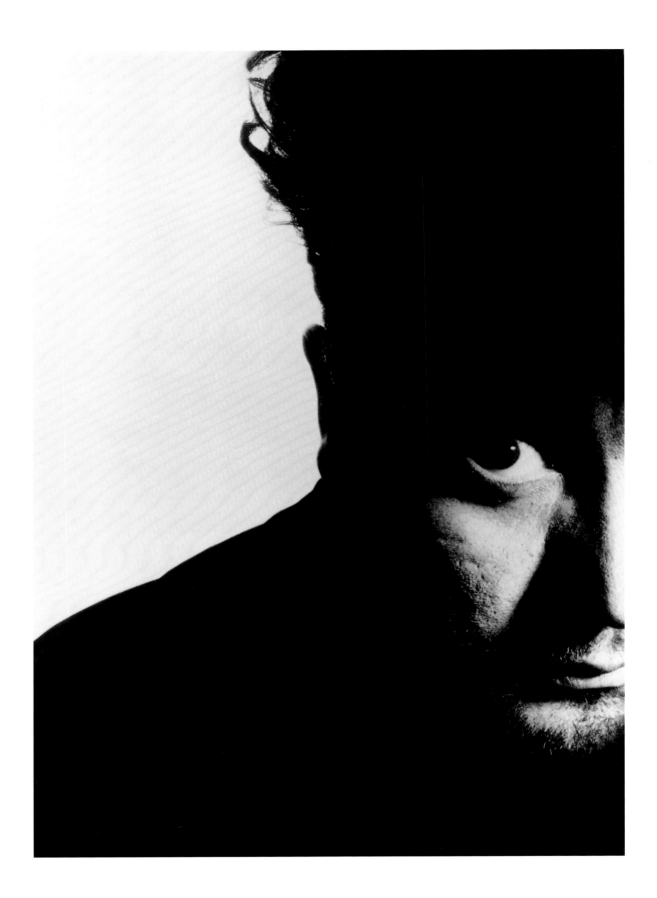

PHOTO Jean-Baptiste Mondino

VASKE Philippe, why are you creative?

STARCK I am creative to be loved. Apart from that, I had a special problem when I was young. I was a real sweet kid, almost dumb. But strangely enough, I wasn't rejected by society because I was different, but I was invisible. And if one is invisible, you really get sick after a while and you do everything possible to exist. The one thing, that came to my mind to exist was remembering the invisible man. You know the invisible man from the movie, that only exists when he's robed in some clothes. The invisible man was the first parameter in my creativity.

I asked myself next, how I could become visible? How could I put on these clothes? And then all of a sudden, I remembered that my father was an inventor who created airplanes and other things and that he always said to me: "In order to make a living, the only profession in the world is to look for ideas from your inner self." And then you create further to survive. After a while one got the duty to work not only to survive, but to work for your fellow human beings.

VASKE Does your creativity thrive in chaos or discipline?

STARCK I believe, discipline is an over dramatized word, but I believe in an organization. Because organization is totally liberating. My creativity is a kind of magma which continously is in motion. Because with the projects you see here I'm pregnant between 5 and 40 years. I work very fast and at the end of my pregnancy the magma equals the end result.

Philippe Starck recalls spending his childhood underneath his father´s drawing boards; hours spent sawing, cutting, gluing, dismantling bikes, motor cycles and other objects.

Several years and several prototypes later, he has turned the Royalton and Paramount in New York City into the new classics of the hotel world, and scattered Japan with architectural tours de force that have made him the leading exponent of expressionist architecture. His respect for the environment and for humankind has also been recognized worldwide. Abroad, he continues to shake up the traditions and culture of major cities around the world, with the decoration of the Peninsula Hotel restaurant in Hong Kong, the Hotel Delano in Miami, and the Mondrian in Los Angeles. His gift is to turn the object of his commission instantly into a place of charm, pleasure and encounters.

The world's best museums in Paris, New York, Munich, London, Chicago, Kyoto, Barcelona - all exhibit his work as that of a master.

Prizes and awards are showered on him: designer of the year, Grand Prix for Industrial Design, the Oscar for Design, Officier des Arts et des Lettres, and many more.

Starck touches us through his work, which is fine and intelligent indeed, but most of all touches us because he puts his heart into that work, creating objects that are good even before they are beautiful.

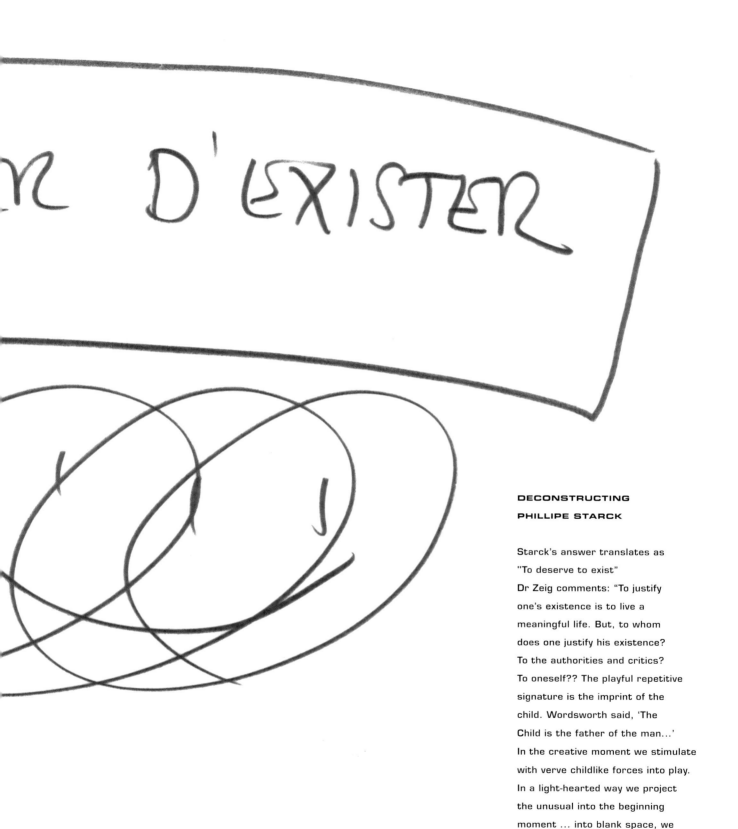

... D'EXISTER

DECONSTRUCTING
PHILLIPE STARCK

Starck's answer translates as
"To deserve to exist"
Dr Zeig comments: "To justify
one's existence is to live a
meaningful life. But, to whom
does one justify his existence?
To the authorities and critics?
To oneself?? The playful repetitive
signature is the imprint of the
child. Wordsworth said, 'The
Child is the father of the man...'
In the creative moment we stimulate
with verve childlike forces into play.
In a light-hearted way we project
the unusual into the beginning
moment ... into blank space, we
create entertainment."

QUENTIN TARANTINO director & actor

Quentin Tarantino, the wunderkind of the American Cinema, penned his first screenplay, 'True Romance', while working at the well-stocked Video Archives Manhattan Beach. He sold the script, and then did the same with his next venture, 'Natural Born Killers' which eventually wound up in the hands of director Oliver Stone. Tarantino took the money and commenced pre-production of his first own feature, 'Reservoir Dogs' starring Harvey Keitel. 'Dogs' premiered with tremendous success at the Sundance Festival in 1992.

After the collaboration, Keitel called Tarantino: "An enormous talent, who needs to be nourished".

His next film, 'Pulp Fiction', not only brought John Travolta a comeback, but catapulted Tarantino from the cult status generated by 'Reservoir Dogs' into the celebrity-director stratosphere; it swiped the Palme d'Or at the Cannes Film Festival prior to its release and went on to score seven Academy Award nominations. Hollywood subsequently enshrined the boy wonder as the emblem of a new generation of young 'videostore' screen-writers. Tarantino returned to the production side of filmmaking for the anthology 'Four Rooms' and for 1996's hipster gorefest 'From Dusk Till Dawn' [based on his screenplay].

1997 showed the release of 'Jackie Brown', Quentin Tarantino's adaption of Elmor Leonard's 'Rum Punch'.

VASKE Why are you creative?

TARANTINO I do believe that at the end of the day God hands out this to this person and that to that person. You know, you are gonna be a great woodmaker, you're gonna make cabinets better than anybody you know, alright. You're gonna be a filmmaker, you're gonna be a writer, you're gonna be a doctor, you're gonna be a nurse. You have the thing that makes you be the right nurse. Actually at the end of the day, I do believe we are born with things that we do a little better than most of the people that we know or that we meet in our daily lives. I think that's where it comes from. If I have anything it's because somebody gave it to me before I was born.

VASKE It's like a gift?

TARANTINO It's extremely like a gift. I guess the part about it that makes us worthy of it is we've got to now do something with it. And that's not predistined.

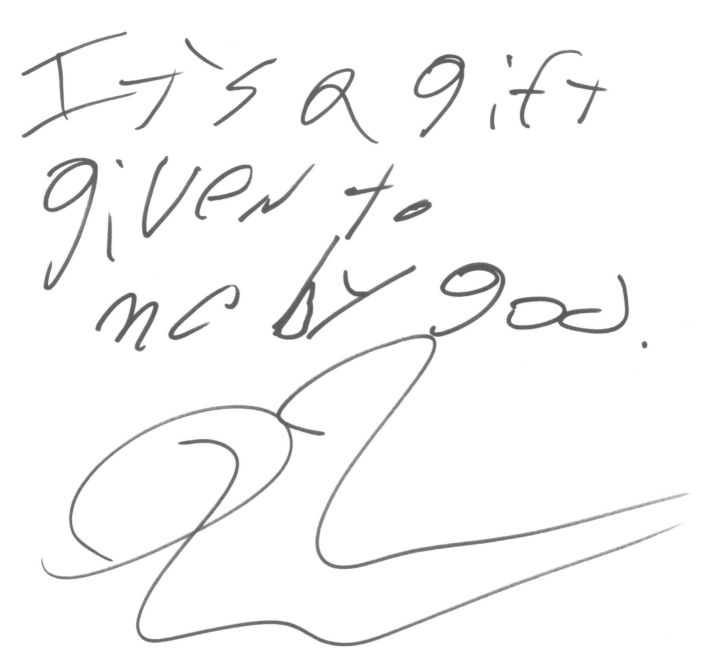

It's a gift
given to
me by god.

DECONSTRUCTING
QUENTIN TARANTINO

Dr Henkel deconstructs: "Quentin Tarantino's creativity is something given to him so therefore he has to use it. It seems that creativity, in his view, is without boundaries. He attributes his creativity to an external force, it is given to him by God, making him the instrument. He is the driver in the driver's seat choosing the direction but it wasn't him who decided to become the driver. All of the above leads to the assumption that Mr. Tarantino may not see himself as being 'that special' after all, thereby making him appear to be a forthright, genuine guy."

Dr Zeig adds: "Tarantino's hastily printed words are somewhat childlike. The rush upward lines of the signature are those of a person who is barely present - someone who is on to the next task. Perhaps Tarantino's god given nature reflects his youthful perspective, a hurried ascendant tumbling into one creative project after another."

Oliviero Toscani was born in 1942 in Milan.

He studied photography at the Kunstgewerbeschule in Zurich from 1961 to 1965, and then began working as a photographer for fashion magazines such as *'Elle'*, *'Vogue'*, *'Lei'*, *'Donna'*, *'GQ'*, *'Mademoiselle'* and *'Harper's'*.

He then switched to advertising and became the creative force behind some of the fashion industry's most famous campaigns such as Jesus Jeans, Prenatal, Valentino, Esprit and Fiorucci.

His infamous collaboration with Benetton began in 1982 and lasted until May 2000. The campaign he created has won him not just a place in history but numerous awards, including the Grand Prix d'Affichage, the Unesco Grand Prix and the Art Directors Club of New York's Management Medal. In 1989 he won the Lion d'Or at the Cannes Festival for a television spot he directed.

Toscani and his family live in Tuscany, Italy. When he is not working he passes his time making wine and olive oil and raising Appaloosa horses.

TOSCANI These people call themselves art director, creative director.
Not even God himself called himself creative director.

VASKE Why are you creative?

TOSCANI In the end I don't really care much about products. I like to work with people that have a good respect for creativity. I think creativity's the only real power left. We can be creative just when we are alive, so I can work, with great pleasure with the people that are... still alive.

I mean censorship is still there, everybody's afraid about their money. The war between creativity and business has been lost by the creative people, by telling them what they do is not commercial enough to be sought. I believe that the economy needs creativity. I say it all time, that the madness of today will become industrial production tomorrow, and could produce incredible fortune. So we need creativity.

OLIVIERO TOSCANI, why are you creative?

"Thank you god for this most amazing
day. For the leaping greenly spirits
of trees and for a blue, blue dream
of sky. And for everything which is
natural, which is infant which is yes."
– e.e. cummings
Cummings was the point of yes,
of affirmation of the spring. Dr Zeig
believes that Oliviero Toscani also
extols 'yes' and finds creativity in God
and affirmation.

PHOTO Volker Hinz

SIR PETER USTINOV actor, director & writer

Two-time Academy Award Winner Sir Peter Ustinov was born in 1921. He is the son of a Russian-German journalist and a French set designer. He grew up in London and made his acting debut there, in scenes he had written, in 1939. He earned an Oscar nomination for his supporting role in *'Quo Vadis?'* [1951, as Nero], and won Academy Awards for outstanding supporting roles in Stanley Kubrick's *'Spartacus'* [1960] and *'Topkapi'* [1964]. He also gave an unforgettable performance in *'Lola Montez'* by Max Ophüls. In later years, he was well received as pompous Belgian detective Hercule Poirot in the Agatha Christie based films like *'Death on the Nile'*. He had one of his best screen roles in years as the sympathetic doctor in *'Lorenzo's Oil'* [1992]. He also performed many television roles and won three Emmy awards for best television actor of the year. He wrote novels and short stories, more than a score of plays, and two autobiographies. Ustinov was knighted in 1990.

His recent projects have taken him regulary to Germany, where he writes and performs scripts to go with classical music, most recently for Mussorgsky's *'Pictures at an Exhibition'*.

Peter Ustinov has been a UNICEF goodwill ambassador since 1968. He has been Honorary President of the Global Harmony Foundation since 1989 and formed the Ustinov-Foundation in 1999 dedicated to understanding between people across the globe and between generations.

VASKE Sir Peter, why are you creative?

USTINOV Creativity is really believing entierly what you see or hear. But finding another angle and seeing the truth in that. That is very much part of creativity, because it means taking yourself out of the shell.

SIR PETER USTINOV, why are you creative?

SIR PETER USTINOV, why are you creative?

Doubt is the greatest spur to creativity I know; what is more expressive of doubt than a blank sheet of paper, an empty canvas, a yet unspoken word?

[signature]

DECONSTRUCTING
SIR PETER USTINOV

Sir Peter Ustinov is a master of communication arts. Dr Henkel describes him as 'expressive, quick and alert': "He seems to be willing to explore the unknown, or in other words, may find pleasure in redefining the well established. He appears to be an imaginative individual."

Dr Zeig adds: "Disequilibrium is the mother of invention. Creation is not possible without ambiguity and tension. Creativity is rooted in the soil of possibility. Ustinov's profile is pensive and at ease. It is complacent, perhaps indifferent. Yet, it has no legs to stand on; it is 'anchored' in doubt."

WAYNE WANG director

Wayne Wang was born in 1949 in Hong Kong and was named after John Wayne. Wang was educated by Irish Jesuits. In 1967 he moved to California to study painting, film and television.

Having worked for American and Hong Kong television, Wang got involved in the sponsorship of Asian immigrants in San Francisco. This helped him realize his first movie in 1982, 'Chan is Missing' – one of the most successful independent movies in the USA at that time.

Two years later he produced 'Dim Sum', a film relying heavily on an amateur cast. This was followed by 'Slamdance' in 1987, 'Eat a Bowl of Tea' in 1989 and, in 1993, by the opulent Hollywood version of Amy Tam's 'Joy Luck Club'. Serious critical acclaim followed in 1995 with the comedies 'Smoke' and 'Blue in the Face', starring Harvey Keitel.

In 1997, during the period of the Hong Kong hand over, Wang directed 'Chinese Box' starring Jeremy Irons - a problematical shoot due to the security surrounding the event and interference from the Triads. Amongst other awards, Wang's 'Smoke' won the Silver Bear at the Berlin Film Festival in 1995.

VASKE Why are you creative?

WANG I think it's because my family's very boring, so to speak, very middle class, and I grew up always trying to be different from that. I was always trying to understand what else is going on, maybe what other secrets, what other mysteries, behind this sort of boring facade. I think that's the main reason why I'm creative. I was left alone as a kid a lot with my grandmother, who was always sticking things up her arse because she couldn't go to the bathroom. I think that was the beginning. And she was very religious. She was always listening to the radio, religious programmes. And I think I was always trying to understand something more than just this very wholesome middle-class background. It could be. I mean there's a part of me that's very dark.

DECONSTRUCTING

WAYNE WANG

For Wayne Wang, creativity
is like an enema bursting
with pent-up thoughts,
emotions and feelings.
The only way to unlock
them is through the sudden
release of creativity.
For Wayne, creativity is the
pleasurable release of this blockage.

EMILY WATSON actress

Emily Watson was born in London on January 14, 1967. She majored in English at Bristol University and then moved to the Drama Studio in West London before finding work in regional theatre and, later, at the Royal Shakespeare Company.

Her extraordinary career took off when she met Lars von Trier, who gave her the female lead in *'Breaking the Waves'*, which brought her her first Oscar nomination and the European Film Award. Emily received her second Oscar nomination for her role in *'Hilary and Jackie'*, in which she played the exceptionally talented cellist Jacqueline du Pré, whose life and career were cut short by multiple sclerosis.

In 2000 she was nominated for the British Independent Film Award in the category 'Best Actress' for her role in *'The Luzhin Defence'*.